CAPTURE YOUR STYLE

AIMEE SONG

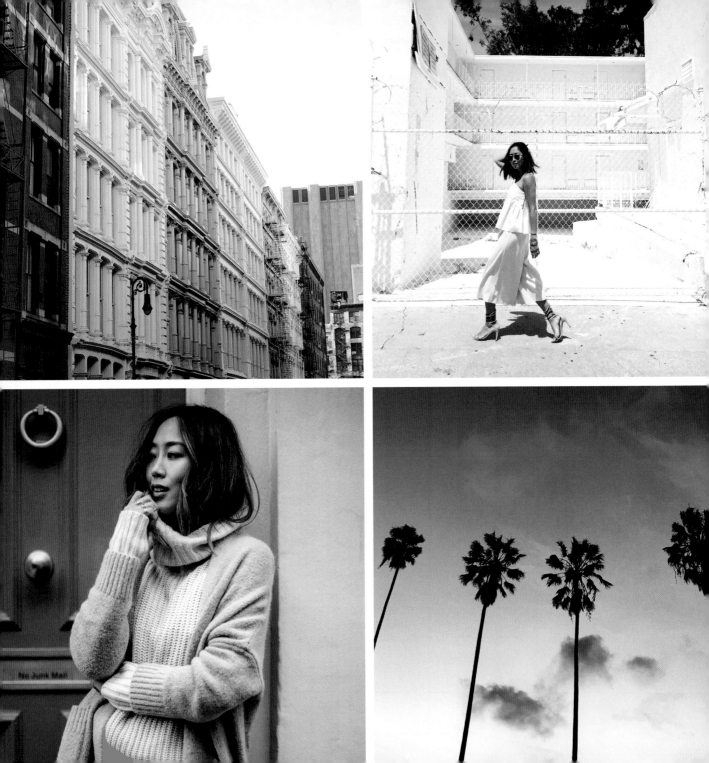

CAPTURE YOUR STYLE

TRANSFORM YOUR INSTAGRAM IMAGES,
SHOWCASE YOUR LIFE, AND BUILD THE ULTIMATE PLATFORM

AIMEE SONG

WITH ERIN WEINGER

ABRAMS, NEW YORK

BY

DIANE VON FURSTENBERG

As one of the fashion industry's most influential bloggers, Aimee Song is living her American Dream. With one perfectly curated Instagram photo at a time, she has become a symbol of today's successful, stylish young woman.

When I first embarked on my design career, I was eager to connect with American women and traveled from city to city to find out what they really wanted. I tied wrap dresses in fitting rooms all over the country and listened to their hopes, fears, and desires. I have always cherished that dialogue and intimacy—it informed my work and kept me connected to my core audience.

Instagram is a fascinating way to communicate because it is about intimacy, of course, but it is also all about immediacy. In real time, you can express yourself to the world, from the places you go to the print you are wearing. Within seconds, I can learn how many people like a dress I designed, or don't like it, or would prefer it in purple. It can become rather addicting.

No one understands or has been able to tap into that addictive quality quite like Aimee Song.

As a leading influencer on Instagram, Aimee has mastered the art of documenting daily life.

She has incredible charm and a sharp eye, and is able to capture emotions by elevating images and showcasing her chic personal style. And luckily for us, she's sharing her know-how with great insight and generosity.

Most important, Aimee understands that authenticity and transparency are the order of the day. I can relate to her desire to create a real dialogue with her followers, creating a community and connecting in ways I never thought possible through social media.

Instagram has captured the hearts of millennials (and just about everyone else). It has become a visual diary for a generation, allowing users to share photographs of the people, places, things—and clothes!—they love most with the people who most want to see them. When Aimee first told me about this book, I thought it was incredibly timely. There are so many aspects to Instagram, from composing beautiful photos to boosting your business, and she has finally written a guide to the platform that addresses everything that goes into a successful feed (and brand!). The book is equally interesting to anyone who wants to understand how millennials think and see the world, and I'm so impressed by Aimee's candor and honesty about the process.

Today, I still make time to drop by the dressing room, but I also find social media a great way to communicate with women. Instagram and other platforms have made it possible to have the most intimate of exchanges—with just the click of a button.

The most important thing, in Instagram and in life, is to know who you are and stay true to that. And Aimee's guide is a wonderful place to start.

When I was seven, I read an article about kids my age writing letters to kids who lived in places I could only dream about from my bedroom. The ability to connect with different cultures and learn about someone else's daily life from thousands of miles away seemed like the coolest thing in the world, and soon I was corresponding with new friends as far away as Australia and Indonesia.

The love and drive for human connection—something so prevalent in social media—has always stayed with me.

It was with me in middle school, when I was bullied and I turned to a Korean social media network called Cyworld, where I was able to connect with people who shared my hobbies and interests, even though I spent a lot of time feeling really alone at school.

It was with me in high school, when I was turned away from the cheerleading squad and a chorus group, but I found thousands of people on Xanga—one of the earliest blogging platforms—who also liked to share funny memes, photos, and stories about how they sometimes felt alone, too.

Despite my love of early social media sites and exploring how they were used to foster connections, I never actually planned on becoming a blogger—let alone named as one of the most influential bloggers by the same fashion magazines that have always inspired me. But in 2006, after my family ran into some financial problems, I put my dreams of attending interior design school

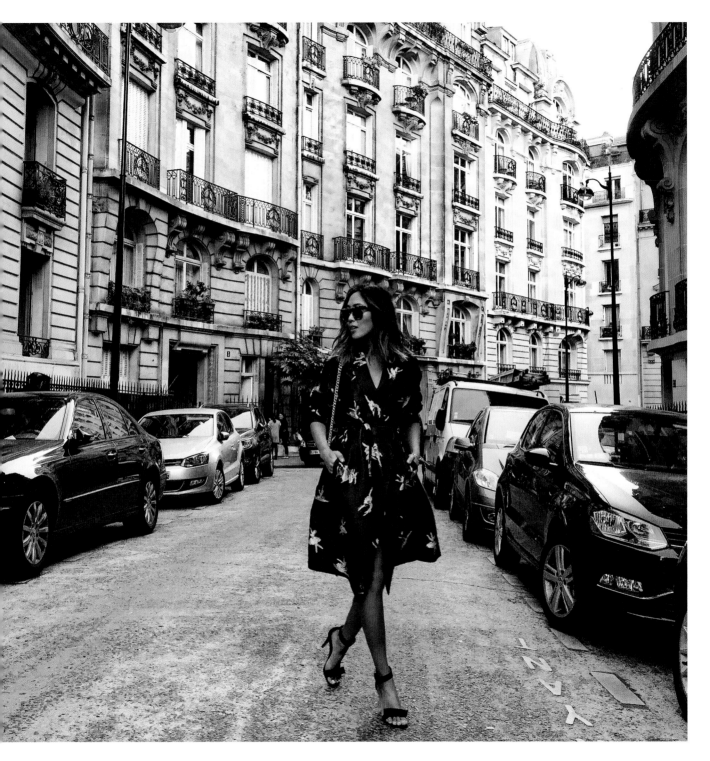

in San Francisco on hold so I could get a job and help my parents make ends meet.

A kitchen-and-bath design firm near my house was looking for a receptionist, so I took the job and found I had time to peruse the Internet during downtime. I researched blogs, interior designers, artists, and other creatives who continue to stir me to this day. After work, I'd continue my "studies" and sit in the corner of the bookstore until it closed, soaking up all I could in interiors magazines and art and design books. I would have taken them home had I not been saving every cent for school.

My dedication and love of the subject paid off when my boss moved me off the reception desk and let me work with clients. Soon I was actually helping people design their kitchens and bathrooms and, eventually, the rest of their houses, too. I was sketching architectural drawings, choosing finishes, and, most important, connecting with our clients and helping interpret their tastes into a home they loved. It

made me feel so good to make other people so happy through design. And after three years of working my butt off, I finally saved enough to go to design school in San Francisco, just as I'd dreamed.

While I was attending school in 2008— and still very much active on Xanga and, then, MySpace—I decided to start my own interior design blog. I loved doing it, and my followers and the people I followed seemed to truly enjoy the pictures of the mid-century modern and layered Hollywood Regency rooms I would post.

Until I tried something a little different: my first outfit post. It was yellow and blurry and something I would never post now. But for whatever reason, it got a response. A good response. And it was fun. Although I didn't realize it at the time, my fashion and lifestyle website, *Song of Style*, was officially born.

Design posts became less frequent as outfit posts became my obsession. I remember the first time a brand reached out to me to send me cloth-

ing. I was shocked. *Send? As in, for free? Where do I sign up?* It was a pair of jeans that I would have bought in two seconds, so I couldn't wait to wear and share. The more I posted, the more my "following" started to increase, and the more brands started emailing me. My life didn't really change right away (except for the amazing swag), but, little did I know, a new app was in development that was going to revolutionize the way I'd share my style with the world.

When Instagram launched and I joined alongside my fellow style bloggers, my picture-taking habit vaulted to an entirely new level. I could do a few daily, showcasing details of what I was wearing, as well as other tiny but beautiful moments throughout the day (from a Sunday-brunch feast to my sister and I laughing during an impromptu photo shoot at home to the details of a gorgeous handbag I couldn't wait to wear out on the town). It became a mini docu-journal of my life, a creative outlet that made me really happy to work on.

Suddenly, I couldn't do anything without a "gram" to go along with it. (If a tree falls in the forest and no one is there to gram it, did it really fall?) I was able to inject my personality into the photos, be it with funny faces or silly commentary. Even as I perfected my photo-taking skills, I kept my sensibility real. I never take myself too seriously, and that honest point of view, always personal—maybe even too personal—is what I think resonates with people.

A few hundred followers became a few thousand. . . . A few thousand became ten thousand. . . . Ten thousand became fifty thousand. . . . Fifty went to one hundred thousand . . . then two hundred thousand. Mind. Blown. I had no idea this was even possible. I started to take my Insta photography more seriously, until it eventually became a career. One day, I looked up and the number had hit one million. That million-mark morning, I got a giddy call from my mom, like I had just been nominated for an Oscar. And even though I wasn't practicing any acceptance

speeches, it was a total honor.

But it wasn't luck that made my following (and double-tap "likes") grow. There is a bit of a science (with some magic) to it. It boils down to branding, how you take photos, subject and content, the art of the caption, and paying close attention to what works and what doesn't, as well as times of the day that posted pictures perform the best (and worst). Even if you aren't jetting off to Paris for the weekend or don't have the latest "it" bag of the season, you can still take gorgeous photos that allow you to reveal your passions— and build a significant following in the process.

I mentioned earlier that Instagram became a creative outlet for me. I experimented as if I were in photography school, toying with different angles and filters, then analyzing everything for the best results. And as my photos improved, even *more* people took notice.

As my following increased, life-changing opportunities presented themselves: invitations to the best events on the planet (Golden Globes,

Oscars, Grammys, fashion shows, parties from L.A. to Morocco to Japan—things I never imagined I would experience firsthand). I still can't believe the doors that have opened because of Instagram. I pinch myself daily.

Today, with 3.3 million followers (at the time of this writing) on @songofstyle, one of my pictures—my view of the Michael Kors fashion week runway show (where I am somehow sitting in the front row; totally surreal even after a few seasons) or my favorite coconut cheesecake in L.A. (believe me, I'm as grateful for that, too)—may get five figures worth of love.

I now feel qualified to say that I know what's up when it comes to Instagram. (A video I posted to YouTube last summer about taking a good Instagram shot currently has 343,000 views.)

I know I'm not alone in my Insta obsession (insert emoji needle and iPhone here). Instagram has taken over the globe. It's the fastest-growing social network online, surpassing 300 million users in record time. More than seventy million

photos are shared on Instagram every day. Seventy million! It has fostered and enabled creativity in not just me but in everyone who makes and shares content. Instagram has not only given me a voice but also has allowed me to learn about others' lives as well—in India, Africa, New Zealand—all in real time. Like my pen-pal days, only better. And it's so much more than just a platform for pretty pictures. It's a major marketing tool for brands, a place where Beyoncé drops her albums, and a hub where products can be promoted and therefore sold. It's where people come together to raise money for a cause (I once got thirty thousand app downloads to benefit brain cancer research because of a post), and where so many young people all over the world find and connect with a community that offers support in the absolute worst of times (never forget #JeSuisCharlie).

It's also a kind of family in real life, too, where #InstaMeets (events that bring together anywhere from just a few to hundreds of avid grammers) breed friendships and open you up to new ideas. When I have hosted events and used my Instagram to share where I will be and when I'll be there, I have met sometimes thousands (yes, thousands) of "likers" and found inspiration from people I may never have met or known any other way.

Instagram has given me intros to great new restaurants, jeans, lip glosses, charities, stores, and artists. And at least twice in Dubai, it helped me connect to a friendly face in a country where I didn't speak the language or know anyone.

At its core, the app is a platform for discovery, art, new ideas, and exploration. It has made a huge impact on my life and my career. Everyone from housewives to photojournalists reporting from war zones uses Instagram to communicate. It is a news source for my generation. (When something drastic happens in the world, my peers turn to Instagram and search hashtags before turning on the TV or going to CNN.com.)

While everyone has his or her own unique purpose and reason for using it, Instagrammers

have one thing in common: They want to put their perspectives out there and receive recognition for doing it.

I owe the app so much gratitude. It is through my blog that I came to realize my ultimate passions outside of design and fashion (and eating, of course): to share information and inspiration, to entertain, and to connect with others. And Instagram allowed me to take my passions global. That's largely why I decided to write this book. I want you to be a rock star on Instagram and perfect your smartphone photography skill set, acquiring fans and keeping and converting followers.

There's a lot that goes into a good photo (and a lot that separates a good pic from an *uh*-mazing one). And there are definite "don'ts" (no one wants Insta shame). This book is full of every trick of the trade that I have uncovered, so you will get noticed by posting pictures that pop, crafting a point of view, and telling stories through standout visuals that capture attention.

While this book is meant to be a guide for turning even a mundane moment into the most beautiful one, unleashing your inner innovator, and realizing your CMO abilities, it's also designed to inspire you to live a life that's actually worth capturing. I delight in getting followers and likes as much as the next girl, but I don't think numbers are the be-all and end-all of Instagram success. Once you nail down a photo style that showcases people, places, and moments you love, I hope you'll use this book to guide you on how to take and produce gorgeous photos that will help you achieve all your Insta goals.

By the end, you'll feel like a bona fide shutterbug, able to spot a gorgeous detail and turn it into viral gold. Here you'll get some helpful advice for showcasing your point of view and even, if you want, driving revenue because of your following (without selling out or doing anything that would dare question your integrity, something I would never—and have never—done, no matter how big the paycheck).

But the ultimate reason I wanted to write this book is really simple: I want to share my love of the human connection—which I am so incredibly grateful to now have with friends, fans, and followers all over the globe, just as I wished for when I was a kid.

I also want to empower you, whether you need the confidence to start an e-commerce business or simply want to share special moments with your ten best friends. Photos evoke feelings surrounding our most cherished moments in life. And Instagram opens our imaginations and connects those moments to others who, if we're lucky, will feel what we feel, too. It has done so for me, and I want it to do so for you. While people always say, "Stop to smell the roses," I say it's much more fun to stop, smell, snap, and share the flowers that brightened your day. Then know that your photo brightened someone else's day, too.

XOXO

Aimee Song

Insta Terms

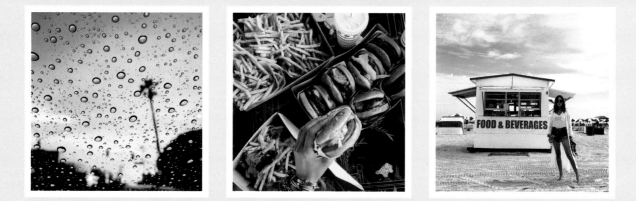

Before we dive in, here's a quick rundown of some essential Instagram terms you'll find on the app and throughout this book.

FEED

Your Instagram account, where all your photos live. Expect exes, former roommates, and nosy colleagues to scroll through this in order to see what you've been up to since first joining the platform.

POST

A single photo that you upload and set free for all the Insta world to see (or just your own followers, if setting your account to private is your thing). Your individual posts constitute your feed.

HANDLE

Your Instagram username, preceded by the @ symbol. I'm @songofstyle, and you should probably follow me now. Speaking of which . . .

FOLLOW

When you choose to "monitor" someone else's activity so that their photo posts will display in your home stream . . .

HOME STREAM

The stream of photos composed of posts by the accounts you follow. (Don't worry—later in this chapter, I make suggestions of awesome people and brands to follow so that your home stream won't bore you.)

LIKES

The things you will collect when followers "double tap" your photos and vice versa. You will become semi-obsessed with refreshing your screen in order to see how many of these you get within the first five minutes of posting a photo.

CAPTION

The text you write to accompany a photo post. This can range from the hilarious to the self-deprecating, the prolific to the cynical. Or, you can simply type a ridiculous emoji and call it a day.

HASHTAG

A single word or phrase without spaces that, due to the addition of the # symbol, makes said word or phrase discoverable to the Instagram community. #HowGeniusIsThat?

#LATERGRAM

When you post a photo later than when you took it.

#TBT

Throwback Thursday. This is a popular crowd hashtag that has caused people to post baby photos, puppy photos, dorky braces photos, and anything else from back in the day on—you guessed it—a Thursday.

#OOTD

Outfit of the day. A photo of your outfit on any given day, sometimes taken by an upstanding citizen, sometimes taken as a mirror selfie.

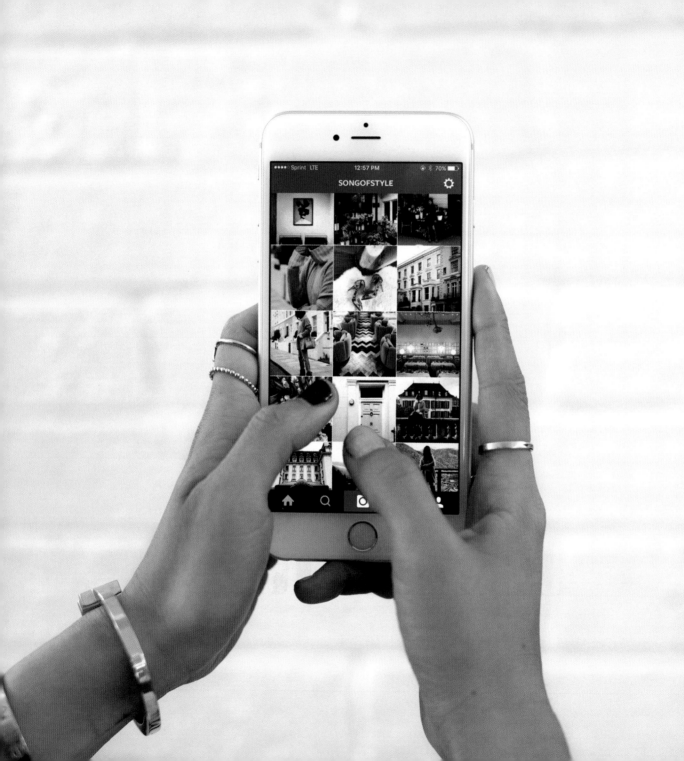

1

THE INS & OUTS OF INSTAGRAM

18–43

Congratulations, you just made the decision to up your Instagame—and, by default, your mobile-photography game! When I started working on this book, it was really important to me that I create a true manual that everyone could use—from the Instagram hobbyist with ten followers to the entrepreneur using the platform to launch a multimillion-dollar clothing line.

It takes some major elbow grease and dedication to get to the top of the Instagram heap, but that doesn't mean that you should feel any pressure to dive in headfirst—unless that's what you want. Above all else, Instagram should be fun. It's not only about taking the perfect picture; it's also about capturing your favorite moments. And this book—no matter how serious or playful your Insta goals—is going to help you become a better mobile photographer who will be well equipped to use Instagram however you want.

Let's start with the basics. In this chapter, you'll become well versed in:

- The nitty-gritty of a camera phone—my personal equipment of choice when gramming.

- How to pick a memorable and effective Instagram handle.

- The best way to find interesting people to follow and start building your feed.

- How to plan your grid (and what the hell a grid even is).

So grab your gear and let's do the damn thing.

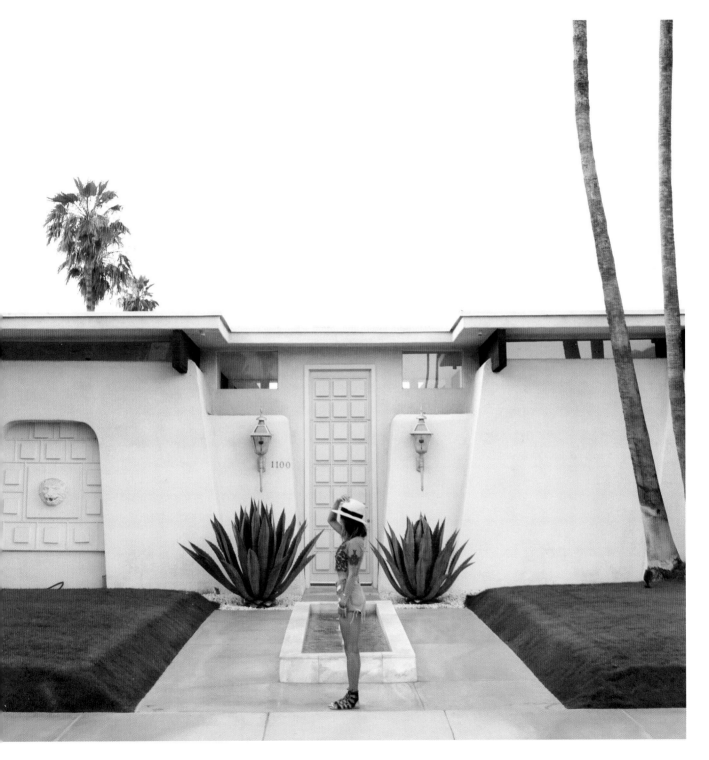

Camera Phone 101

It's probably safe for me to assume that you've heard about Instagram. But for anyone who has been taking a digital (and cultural) detox a little too seriously, here it goes: Instagram is the world's fastest-growing media platform that has more than 300 million users who share more than 70 million photos. *Every. Single. Day.* That's incredible (and kind of insane), and it shows just how vast your Insta audience can be if you want to promote a blog, project, business, or the like. (Or you can totally make a private account and only let your mom and sister see your vacay snaps, if that's more your speed.)

To get started, you'll need the right equipment—a mobile phone or tablet with iOS/Android capabilities or a Windows 10 phone (or better). Nothing else will do (Zack Morris phones not accepted). You'll need to download the Instagram app and create your account from your mobile device, not a computer (though you can look at accounts on a desktop). Even though a quick spin around your average fashion blogger's

Insta feed feels like you're looking at a series of elaborately planned magazine photo shoots, you absolutely do not need a professional photographer to follow you around or even a fancy pro camera in order to take flawless Insta pics. Even an iPhone 5 from 2012 has the same 8-megapixel camera with similar picture quality that's featured on Apple's newer models, albeit without some of the autofocus and video coolness.

If you do happen to want professional-quality pictures on your Insta feed, you can certainly buy a pro camera and upload images to your phone for posting, though I personally don't think it's necessary. I use my iPhone most of the time for my social media snaps.

For blog posts, I trust the Sony Alpha A7S and Canon EOS 5D Mark III, both professional full-frame cameras. I have total respect for DSLRs, but let's face it, a mobile phone is lighter, more accessible, and built to be carried everywhere. I can't slip my Canon into a clutch for a fashion show, and traveling with a bulky camera

can be a major buzzkill. And that doesn't even include capturing everyday unexpected magic—ad hoc moments that beg to be photographed. This is a grab-your-phone-and-go world, so my best advice is just to embrace it.

There are a ton of souped-up photo apps you can download to enhance your phone's standard camera feature (Camera+ is one of them). I use my iPhone's standard camera and all the different modes that come with it (see below).

Now, there are a few basic phone photography functions and skills that will become your new best friends, regardless of what type of photo you take (see opposite page).

TIME-LAPSE

A video mode that speeds up images.

SLO-MO

Time-Lapse's much slower, lazier cousin.

VIDEO

A regular moving-image recording.

PHOTO

Your standard 4:3 aspect-ratio image. As of 2016, you can post this aspect ratio to Instagram.

SQUARE

Before you could post 4:3 images to Instagram, you could only post photos with a square 1:1 aspect ratio, which this handy 1:1 crop captures automatically without any resizing work.

PANO

If you can walk a straight line, you can use your iPhone to take cool panoramic photos. Sadly, these don't really fit on Instagram. But they're awesome nonetheless.

GRID LINES

AUTOFOCUS & FOCUS LOCK

EXPOSURE ADJUST

Regardless of the operating system, your phone camera will have a grid, which is vital for making straight images (crooked pictures are my absolute nightmare). On Samsung devices, you can find the grid by launching the camera, going to Settings, and scrolling down until you find Grid Lines. Make sure it's on. On an iPhone or iPad, go to Settings and scroll down to Photos & Camera. Then scroll down to Grid and slide that bad boy on. Now you'll be able to line up your intended images in the grid to keep everything pretty and straight (we'll get into the nuts and bolts of composition later). This will change the way you take pictures. Trust.

This key feature allows you to point your phone at your subject and tap your screen until you get the focus you want. A simple tap-to-focus is fine when your subject isn't moving. But take it from someone who has tried (and oftentimes failed) to take pictures of models sashaying down runways: It's hard to get a non-blurry photo when your subject is on the move. The solution? Focus lock. Instead of a dainty tap on your iPhone or iPad screen after launching the camera, hold your finger down for about two seconds. You'll see a yellow AE/AF lock banner appear. Similarly, on a Samsung, press and hold to focus, and wait for the lock icon to appear. And, voilà. Clear photos, no matter what.

If you have an iPhone or iPad, you may already know that once your camera is open, you can tap a light part of your subject to darken your image or tap a dark part of your subject to lighten it up. (You can also move your finger up and down to brighten or darken— a hidden gem of a trick that I don't think everyone knows about; you do this when you see the icon of a small sun appear.) You'll learn later that a too-dark photo is much easier to fix than one that's blown out and too light (and I do like a light image), so take advantage of exposure features, no matter what kind of tools are at your disposal.

What's in a Name:
Choosing Your Handle Wisely

Your Instagram handle is your calling card—the public moniker that will appear at the top of your profile and shout your brand, personal or otherwise, to the world. Want to leave a comment on a friend's photo? They'll know it's from you based on your handle. Planning on sending a direct message (DM) to a potential client? Your handle is what they'll see in their inbox. If you so desire, this is also what you'll put on your business card, email signature, and website to send eyeballs (and potential followers) your way; you can also add it to your online dating profile so that potential Prince Charmings can find your cute selfies.

Picking a solid username isn't rocket science, but there are a few things to keep in mind when choosing one. (Luckily, Instagram lets you change your name later if you need to, but that doesn't mean you shouldn't go for something stellar right off the bat.) The best option when picking an Instagram handle is to use your name. Mine is @songofstyle—the name of my blog—while my sister Dani is @songdani, her name flipped. And Two Songs, our line of products, is @shoptwosongs, which is easy to remember and has the added perk of reminding our followers to—what else?—shop.

And those 300 million users I mentioned? A lot of them use their names, too, so that doesn't leave a ton of options—especially if you're trying to use a common moniker.

A FEW WAYS AROUND THE SAGA OF THE TAKEN NAME

Put your last name first (*@songdani*; *@chungalexa*).

Add your middle name. Model and actress Dree Hemingway uses *@dreelouisehemingway*; fashion DJ Harley Viera-Newton uses her middle initial: *@harleyvnewton*.

Play with initials. Designer Christian Siriano is *@csiriano*; actress and fashion blogger Jamie Chung is *@jamiejchung*.

Add "the" in front of your name. Technically, it's not his real name, but Insta sensation Josh Ostrovsky uses his "stage name," *@thefatjewish*.

Add "real" before or after your name—even if you're not famous. (Supermodel Caroline Trentini— *@trentinireal*—is an example.)

Throw in an "its" or an "i am" in front of your name à la designer and Moschino's creative director Jeremy Scott (*@itsjeremyscott*) and *E! News* host Catt Sadler (*@iamcattsadler*).

Shorten your name or use a nickname. *Dancing with the Stars* performer Julianne Hough is *@juleshough*.

Add your location. Designer Alexander Wang is *@alexanderwangny*.

How about a courtesy title? *Glee* star Lea Michele is *@msleamichele*.

Are you a writer? Designer? Lawyer? Throw your profession into your handle, and if you're not into your profession at the moment, describe yourself in the way you want to be seen (not a bald-faced lie, but a little bit of spin never hurts—it's Marketing 101). Justin Bieber's stylist Karla Welch is *@karlawelchstylist* and Anne Hathaway's stylist Penny Lovell is *@pennylovellstylist*.

If you do not want to use your name, think of your Insta account as a portfolio, and ask yourself what you want your brand to convey. Think of synonyms and words in other languages that have meaning to you as a way to find something that sounds catchy and cool.

You can also add an underscore, which can actually make it easier for people to read your handle. One is fine (@aimee_song) but I would advise against multiples (@aimee_song_of_style) because it's harder to find with Instagram's Search and Explore feature.

Also avoid numbers when creating a handle. People forget numbers, and they, much like double_underscores_, complicate things. You want to snag something simple and memorable—especially if you're planning on using your Insta feed to promote a store, business, blog, or anything else that leans toward the professional. You're far too busy to be giving prospective followers a spelling lesson anyway, so try to keep things sweet and simple.

Leading Through Following:
People You Want to Know

Instagram is one giant community where you can find people who move you, who share common interests, or who just take cool pictures of things you want to see (a travel blogger traipsing around Tahiti always lifts my Monday-morning vibes). And now that you have your shiny new account, you have to find great people to fill your feed and take you on a journey as you make your way through it.

First, the basics. In the upper right-hand corner of your Insta profile, there's a cog icon (or three vertical dots, if you're using Android). Tap it, and you'll be taken to the area of your account that lets you edit your profile, change your password, and make your account private (more on that one later). This is also the screen that lets you find your Facebook friends and email contacts to follow. You'll have to give the app permission to connect with your contact list, and then you can cherry-pick whom you want to follow. Easy.

Using the "Follow People" feature isn't for everyone, since it lists contacts from your other social media accounts and, quite frankly, can feel kind of creepy (maybe the high school prom date you happen to be Facebook friends with doesn't need to see pictures of your post–high school adulthood). Same goes for the prospective client lurking in your Gmail contact list (not that your Mexico spring break pics aren't cute for a different audience). Side note: It's important to understand that nothing really goes away online, even if you delete it. Someone, somewhere has a screenshot, and it can haunt you. Think about what you want to put out there before doing so,

and make sure nothing is questionable. If you are applying for a new job, you can bet HR is scanning your feed, so proceed with caution.

Another great way to discover interesting accounts is with Instagram's Search and Explore feature. Tap the magnifying glass at the bottom of your feed to see which hashtags are trending (we're gonna talk about hashtags very soon, don't fret), groups of Instagram-curated images by theme (The Best of New York Fashion Week, Fall Football, and Trending Places are just three examples), and a waterfall of photos that Instagram thinks you might like based on your following and liking history (no sweat if you don't quite have a history yet—the great minds at Insta will send suggestions anyway).

Once you start clicking around, you'll likely find photos that interest you enough to make you investigate their owner's profile, which will lead you to scrolling down that person's grid (that's the set of tiles that composes an account's photo waterfall—more on that later, too), and

you'll get lost in the Instagram rabbit hole— or the Inst-abyss. You can follow suggested accounts based on people you already follow by clicking on the arrow next to the follow or "following" button.

The best way to discover brilliant accounts is to get lost in the community. Scroll through profiles, double tap to "like" photos you love (it will help your Explore page to populate with what you actually like), and check out the accounts that those you admire are following. If you happen to see someone tagged in a photo you like (a tag is when a poster adds a handle to a photo caption or the photo itself, making it "clickable," hence, findable), tap on it to see that person's account, as well. Then do it all again: Scroll down their photo grid, dig around, and see which users they follow. Lather, rinse, and repeat a few times (or a few dozen times, depending on how bored you are at work or the level of insomnia you're dealing with) to curate what you see in your feed and cultivate your taste.

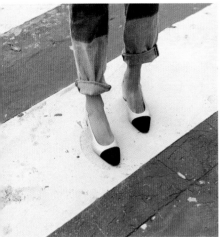
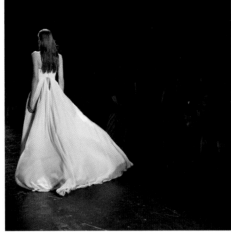
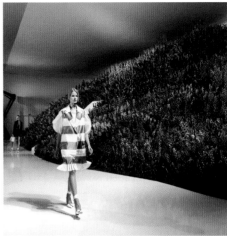
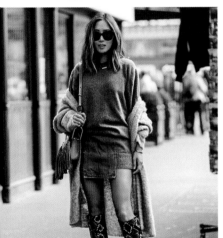
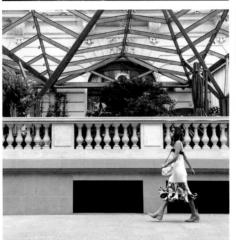
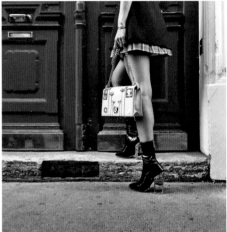

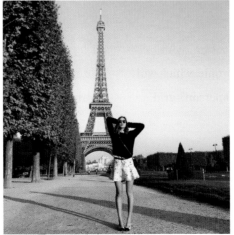
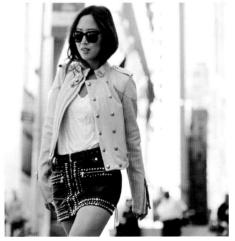

Using Geotags: A geotag, or the location where an image was taken, is listed just above the photo and under the photo owner's handle. If you tap on the geotag, you'll see a little map above a grid featuring all the other photos that were taken at that same place. Major. I use this feature a ton when I travel in order to find interesting taste-makers and creators; it's my go-to for unearthing the coolest restaurants, bars, and stores. We'll talk about turning Instagram into your own personal city guide later on. But for now, you can definitely play with the geotag feature to grow and customize your feed.

As a whole, you want to geotag and tag your own photos—it's best practice to enhance engagement. And now Insta lets you geotag in other countries regardless of where you are, so you can latergram a shot from a far-flung location when you're cozy in your own bed at home.

I urge you to explore and fall down the gram vortex—the best way to kill time and build your community. To give you a little head start, check out a few of my favorites on the following page.

FASHION INFLUENCERS

@mija_mija
@chrisellelim
@alwaysjudging
@damselindior
@trevor_stuurman
@lucywilliams02
@shionat

FOOD PHOTOG- RAPHERS

@sonyayu
@_foodstories_
@anddicted
@livingthehealthychoice
@framboisejam
@lonijane
@nourishandevolve

PUBLICATIONS & WEBSITES

@voguemagazine
@whowhatwear
@forbes
@cntraveler
@goop
@detailsmag
@britishvogue
@refinery29
@voguerunway
@fastcompany
@vanityfair

ILLUSTRATORS

@timothygoodman
@_thelustlist_
@jasminedowling
@itsaliving

INTERIOR DÉCOR INSPIRATION

@mydomaine
@elledecor
@mrorlandosoria
@ryankorban
@kellywearstler
@onekingslane

TRAVEL INSPIRATION

@cupofcouple
@tuulavintage
@vutheara
@zachspassport
@grantlegan
@hirozzzz
@shackette
@parisinfourmonths

SOCIAL MEDIA GURUS

@amy_stone
@lucylaucht
@cubbygraham
@brandonosorio
@christenebarberich
@laneycrowell

BRANDS

@madewell1937
@mrporterlive
@chloe
@dvf
@michaelkors

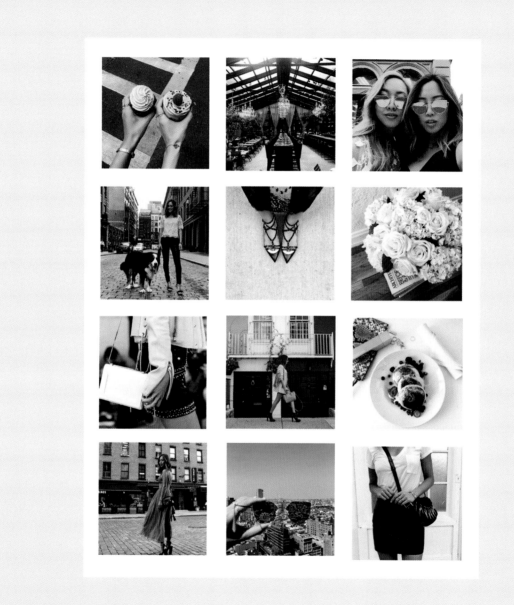

Curating the Ultimate Grid

Now that you've nailed the basics of your new account, it's time to get next-level creative and present your visual story to the world. If a photo is worth a thousand words, your Instagram grid is worth a million.

When I talk about a grid (*not* the photoset grid used to take an image), I'm talking about the set of tiles that makes up your photo waterfall. When you're on your account page, scroll down past your profile photo, handle name, and follower counts and you'll see nine to twelve photos on your screen. Three photos across, three or four photos down. *This* is your grid. You're about to start thinking in twelves.

Your goal is to have the twelve squares that comprise your grid tell a compelling, cohesive story. This can be done in a few ways—by subject matter (e.g., a trip, so you document the beginning—packing/travel—the arrival, the middle, and the end, creating a complete story), by filter type (according to digital marketing company TrackMaven, Lo-Fi, X-Pro II, and Valencia are the most popular filters; your feed will look damn good if you stick to using only one of them, but I often prefer no filter at all and just brightening, sharpening, or highlighting on my own), by color scheme (some people only shoot in black and white or use a soft, washed-out palette for consistency; a black-and-white feed with the occasional pop of color is also chic), or by crop size (you can leave a certain amount of white space around each of your photos for a uniform and polished look).

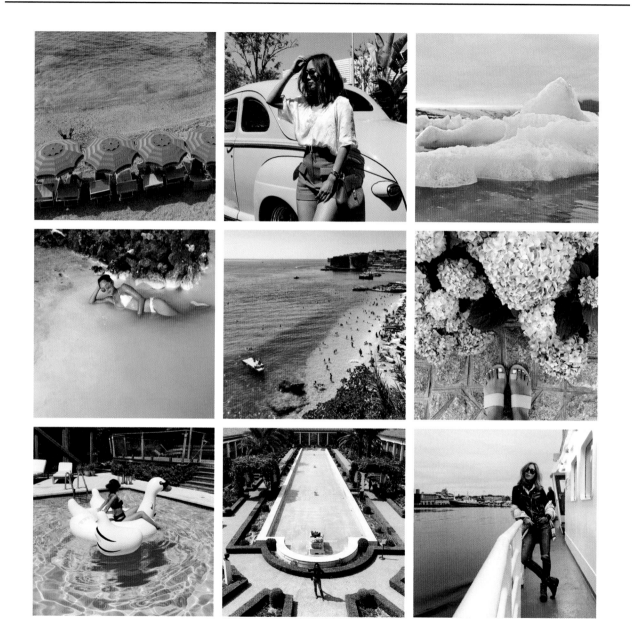

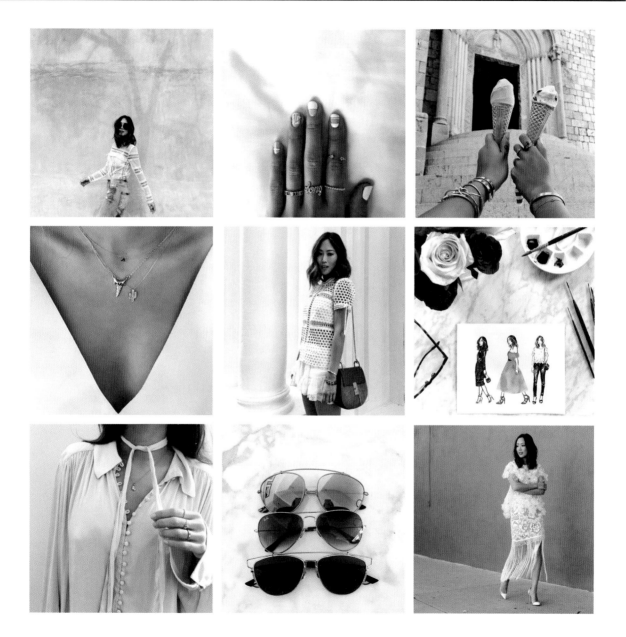

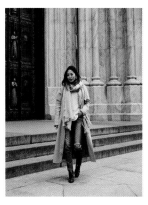
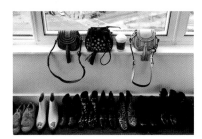
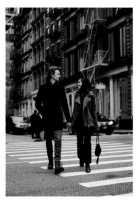

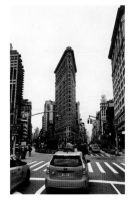
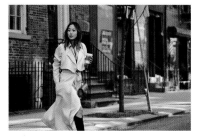
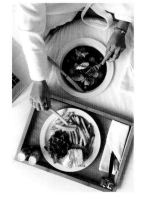

Most people think Instagram is all about perception (what you see is what you get), but it's so much more that that. It can be a community where creatives come together to share their experiences with one another. Sometimes Instagram has a bad rep because people end up just showing off what they have, but it also can be a platform where people gather and inspire each other. Some of these tactics take more discipline than others. And, as you'll hear me say a lot throughout this book, not everyone who wants to share quick snaps is going to devote as much time to their grid. I don't consider my grid all the time, either, and that's totally fine. For everyone else, I have a tip that will set the tone and direction of a feed: Write a mission statement. This becomes the underlying sensibility and criteria for your images.

What's a mission statement, you ask? It's a simple, one-sentence line that defines the reason why you have your Instagram feed in the first place and what you want to achieve with it. The mission statement of @songofstyle is to "inspire and connect with people all around the world through photography, beauty, and passions, whether that's food, lifestyle, fashion, etc."

Your mission statement can be whatever you want, but you'll be most passionate about what you create and share if you find something that feels authentic to what you love most in life. And if Instagram is a platform for your business, your mission statement will have a more professional focus. Maybe you just started a jewelry line and your mission is to transport followers through gorgeous photos of jewels and ultimately convert them into visitors to your e-commerce site (where they then shop). Perhaps you're obsessed with pizza and your mission is to get followers to rely on you for all things cheese and dough. Or maybe you're an illustrator and you want your drawings to land top-tier jobs for your talent (if that's the case, I recommend that you think of the kinds of jobs you want and then curate your feed accordingly, representing a specific style

and tagging the brands you eventually want to work with).

Whatever your mission, write it down and own it. Every time you're about to post a photo to your account, ask yourself whether or not it fits your mission statement. Think of it as a kind of business plan that keeps you mindful of the story you're telling.

Another important point: The average person has the attention span of a goldfish. I don't know about you, but I know that I can get really bored really fast. Would you find it interesting to look at someone's grid if it had twelve squares of the exact same duck-faced selfie? Probably not. So try to curate your photo posts by—again—thinking in twelves. If you have a food photo in one square, fill the next one with something different—an outfit shot, perhaps. Then maybe some gorgeous flowers you saw in the park. Next up, you could post some arm swag, followed by, say, a sunset. Once you've posted three photos and jumped to a new row in your grid, don't be shy to bust out a selfie.

Last, consider how each photo looks next to, above, below, and diagonal to the others. There should be a flow. Perhaps you want your grid to be an ombré of pastels or move from blacks to grays to silvers to pinks before pumping it up to blues, reds, and oranges. (Blue tones always perform better than red as a whole, according to Instagram articles I have read.)

To sum it up: Constantly change up the types of images you're posting so that you always have a story (potentially refer to previous posts to drive people back and keep them engaged); ensure that colors work well together; swear by your mission statement.

Follow these basics, and you've got Instagold.

Your Turn

There are so many good photo factoids ahead that you'll be tempted to read them first, but to see how posting a photo is done, let's do a basic test run. Open Instagram and do the following:

- Tap the camera icon in the bottom center of your home screen—it's nestled between the "search" magnifying glass and a little chat bubble with a heart inside of it (more on that one later).

- Give the app permission to access your photo library in order for you to see all of the photos stored on your phone. You can also toggle between taking a photo or video in Instagram. Tap on a photo (remember, this is only a test).

- Pinch your image to resize it. Want it at its original size? Hit the arrows on the bottom left corner of your photo. Interested in creating a collage of multiple photos? Download Layout, Instagram's free layout app, and tap the multisize square on your image's bottom right corner. Once your photo is zoomed or sized the way you want it, tap Next.

- Now comes the fun part: filters. You'll see a bunch of options, including Mayfair, Valencia, and Rise, which are three OG filters that change the visuals of your image in a really interesting way. I personally don't use these filters, but more on that later.

- When your image is sized and filtered to your liking, tap Next. Write a witty caption that would make even @thefatjewish blush and—if this weren't a test—tap Share, and voilà.

We'll get into the technical in-app aspects—including photo editing with Instagram's tools, geotagging, hashtagging, and tagging in general—in the next few chapters.

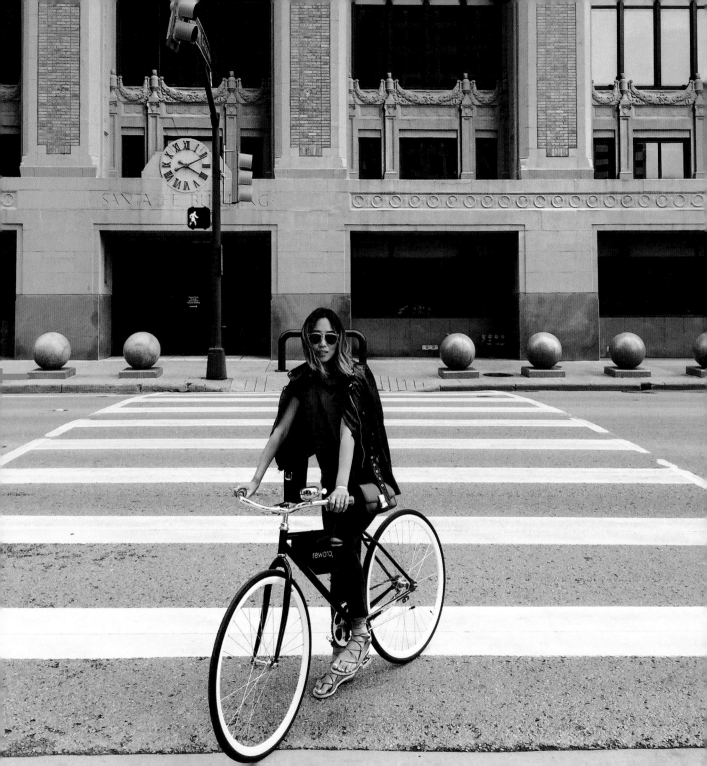

2

CAPTURE
YOUR STYLE

44–117

Party On: *Composing Photos for Fashion Events and Beyond*

As I mentioned before, one of the things that keeps me gramming every day is a photograph's ability to evoke the feeling behind a specific moment in my life that I want to remember and share. And the most effective way to do that is by taking a picture that doesn't completely suck.

Whether I'm at my sister's birthday party, taking a selfie that shows off a cool necklace made by one of my friends, or trying to capture a beautiful flea-market find in my living room, photography is only art in the eye of the beholder. Still, there are some basic rules of composition and editing (yes, editing—it's not a dirty word!) that are universal for taking a great shot (and getting likes) no matter what the occasion.

When I was in interior design school, I took a class called Sacred Geometry, which focused on Leonardo da Vinci and his use of mathematical formulas in his work. I learned that da Vinci used the golden rule (or golden ratio, if you prefer) when creating his masterpieces. Without getting into too much detail, the essence of the rule is that a slightly off-center subject is more desirable than having it in the middle of a frame (thank the great

painters of the Renaissance period for realizing that the human eye naturally wants to roam). I never place myself in the very middle of a photo unless I really think that's the best way to take the shot. (For example, a row of sick sunnies lined up in the middle of a white background is balanced, symmetrical, and simply looks good.) At first it might feel weird to take pictures that seem off balance. But in no time it will become second nature, I promise. And you'll get out of your comfort zone and start doing weird, interesting things with your camera (e.g., creating abstractions, shooting at unexpected angles, making the focal point a corner of a square, and other art student stuff).

Keeping da Vinci's wisdom in mind, one of the most popular basic photography principles is called the rule of thirds. This is where your phone's photo-taking grid is going to come in handy.

Your grid will break down your photo screen into nine parts. If you place your subject's points of interest at intersections of the grid or along its lines, the photo will be more pleasing to the eye.

Now, you don't have to go crazy lining your subjects up just so. Rules are meant to be broken, after all (plus, it gets tricky when you're trying to capture a fleeting moment and it takes you five minutes to get the proportions "right"). You can edit and crop it later if a shot looks wrong. The rule of thirds is merely a great tool to keep in the back of your mind, and it's helped me create some of my most liked pics ever.

You can, of course, get deeper into different composition theories (the Gestalt theory of simplification is worth a Google if you want some heavier reading). But without getting too textbook, here are a few simple paths to compositional grandeur:

Place the horizon line properly. Landscapes tend to look better if you place the horizon line—which is the horizontal line that represents your viewer's eye level (or, in other words, where the water and sky meet at the beach)—slightly above or slightly below the center of the shot.

Frame pattern and texture. If you've spent enough time stalking Instagram, you've likely

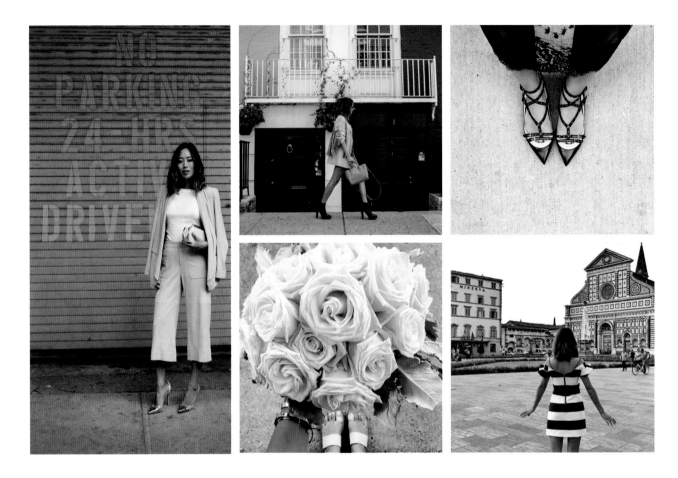

1 2 3
 4 5

1 I was in a rush and didn't have many background choices, so I opted for similar muted tones to my outfit plus a gritty pop of color.

2 I found this interesting architectural feature and wanted to show the movement of my fringed jacket, so I did a walking shot.

3 A simple floor is the perfect canvas for busy but cool shoes.

4 I love flowers and they make for nice photos. My sandals happened to match the bouquet!

5 Florence has a lot of tourists and it's almost impossible to take a photo without them, so I tried to find an emptier area. This is much easier early in the morning.

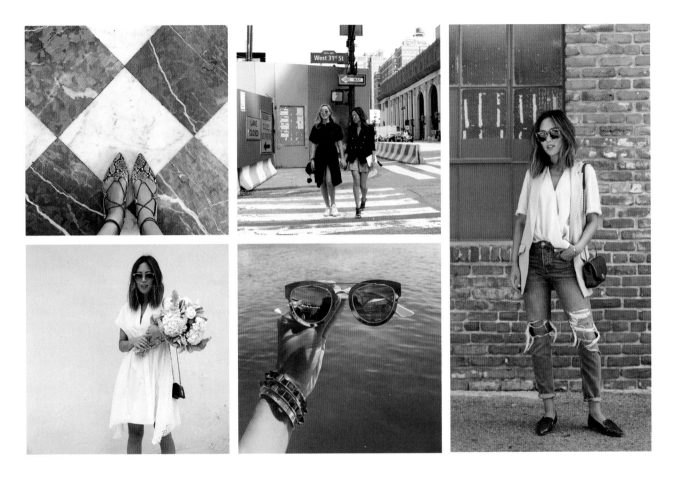

1 2 3
4 5

1 A geometric tile scheme with different color tones showcases my flats.

2 A sister snap in NYC.

3 This casual outfit is complemented by the brick background, as opposed to my posing in front of a more elegant setting.

4 Simple and straight to the point—it's all about the dress and flowers.

5 This photo works because the sunnies are really cool and so is my arm swag. Double bonus for the stunning background and unexpected perspective.

come across more than one shot of someone's pretty shoes on cool tiles (one of my personal favorite types of grams). Aside from the obvious patterns on tile and wallpaper, there are patterns hiding everywhere. Feathers on an animal, for

instance. Or a row of bundled roses or bricks of a building. By filling your frame with the details of your subject, you can create an interesting composition with pattern. Texture works the same way—the wood-grain pattern of a butcher block

in your kitchen can give a homemade cheese plate context and make it come alive (just don't forget the crudités).

Get your lines right. In photography, "leading lines" are the directional elements in a picture that lead a viewer's eyes through a photograph to convey distance. Think of a road that is wide at the bottom of a shot and gets smaller as it seemingly moves upward, eventually vanishing (your eye will naturally travel along this road to its end point). When you're getting ready to take a picture, look at the subject and area you're considering shooting and think about where your eyes naturally stop. Do they immediately zoom to a colored front door? A park bench with interesting graffiti? A vintage car parked on the street? This technique works with all kinds of lines—not just roads. Pay attention to lampposts, deck chairs, or other items in rows, as well as bridges, shorelines, and even the rays of the sun. After you've figured out which line is the most prominent, set up your shot as if it were traveling through your photo from the foreground to the background—either starting at a bottom corner and traveling up or starting at a top corner and traveling down.

Vertical vs. horizontal composition. This one is really easy. If your subject is wide and you don't want to stand twenty-five feet away to get the entirety of said subject in the shot, take a horizontal photo. If you're snapping something tall and skinny (Eiffel Tower, anyone?), go vertical. Pay attention to where your eye travels naturally (either back and forth or up and down) and let your gut be your guide on which format is best for that specific subject matter.

Learn from the masters. I love to page through photography books for inspiration. I don't want to copy anyone, but I always get new ideas from the iconic works of Horst P. Horst, Helmut Newton, Herb Ritts, Richard Avedon, Miles Aldridge, Slim Aarons, Inez and Vinoodh . . . I can go on. Photography books (and exhibits, when they happen to come to town) are a great way to learn technique and also pay homage to the pros.

Editing Your Photos
(And What Apps to Use)

When it comes to Instagram, the word *editing* is often the redheaded stepchild that no one wants to talk to at the party. Sure, editing tools can be used for evil (shaving pounds off your body isn't good for anyone), but when applied in the right way, they can turn good photos into double tap–worthy ones. You don't need to transform yourself or your photos into an unrecognizable state (authenticity is so much better than a heavy hand on an editing app any day); rather, use them to enhance the sharpness, color saturation, brightness, and other technical elements that make an amateur shot look super professional.

Now, don't get me wrong—I break out. My dresses get wrinkled. I stand in positions that look unflattering on camera and get stuck with dreaded "camel toe." And, when it makes sense, I *lightly* fix some of these things (*lightly* being the operative word here) with editing apps. I don't believe in using these apps to completely alter your face or body. But I do believe photos can have unflattering elements that can be edited so that you're presenting yourself in the best possible light. (Fixing photo "blemishes" isn't solely reserved for those that sprout on your face; random cigarette butts on the street or a rogue piece of garbage can also be removed for a better photo.)

I use three apps—Snapseed, VSCO Cam, and blogger-favored Facetune—plus Instagram's own built-in editing tools for my postproduction magic. When thoughtfully applied, working with editing apps almost feels like postproduction for a magazine shoot or a blog entry post. As such, the editing process deserves ample time and energy if

you choose to do it. I have a pretty regimented editing protocol: start with Snapseed for brightness and contrast, then Facetune for any unwanted clothing wrinkles or acne abolishment, and then VSCO Cam for a very, very light filter so that the images in my grid all look uniform (more on page 34).

But before I start fine-tuning, I crop my photo to Instagram's original square-intended proportions. Cropping doesn't necessarily mean cutting something out of an image (though a rogue tourist, lingering shadow, or crumpled napkin ruining the edge of a food shot is fair game for the chopping block), but it helps to use your phone's built-in cropping tools to home in on the image you want to post.

For example, I don't love using my camera's zoom. I think it distorts images and tends to make things blurry and weird. So instead of zooming in on, say, a flat lay of my favorite beauty products so that I get everything into the shot, I'll actually take the photo from a bit farther away (a foot and

a half above is a good starting point, depending on how much you want to get into the shot) and crop to zoom later.

Your iPhone has a built-in editing tool that works for this purpose. Open your image, tap Edit at the bottom of the screen, and tap the icon that looks like two rotating half squares intersecting, just next to the Cancel button. Crop your photo until the subject you want to post fills the square.

Cropping is great for food photos, flat lays, and accessory details that need to stay sharp and clear (again, not ideal scenarios for using the zoom feature). If you'd rather edit your image first and crop later, Instagram has an in-app crop tool that works wonders, too, as do the editing apps I mention below.

Check out the following pages for more detail on how I edit.

1

SNAPSEED

For enhancing the brightness, contrast, shadow levels, and saturation of a photo. My favorite thing about this app is its handy Selective Adjust tool, which lets you brighten, saturate, or desaturate specific areas within a whole photo. So if you happen to be holding a pretty bouquet, you can isolate the blooms and saturate their colors. This is also super helpful if a photo isn't evenly lit and needs brightening in certain spots. I use contrast controls sparingly so that my photos don't have a fake, granulated look that too high a contrast creates.

There is also a feature called Transform, which allows you to adjust the perspective along the vertical six or the horizontal axis, and you can also rotate the image.

2

FACETUNE

Once a photo is bright and clear, import it into Facetune. Since this app is similar to Photoshop in its functionality, it's tempting to get caught in a trap of giving yourself porcelain skin, bigger boobs, a tinier waist, and anything else normally reserved for the plastic surgeon's office. Again, this is your feed and you can do whatever you want to your photos, but I prefer my photos to be real and authentic, so I use Facetune's Smooth tool to smooth out only the most major of zits or unflattering body-angle situations (aforementioned camel toe or see-through shirts that would make my father blush included), as well as any heavy dress or shirt wrinkles that the steamer missed. The app's Patch tool is perfect for getting rid of cigarette butts, and Details—my favorite feature of the app—brings out the details in jewelry close-ups, product shots, and any architectural backgrounds.

3

VSCO CAM

This app is actually its own camera, which I don't use (as I mentioned in chapter 1, I prefer my iPhone's standard camera). Instead, I like VSCO for its collection of super-minimal, clean filters. I don't use heavy filters on any of my pictures and I especially never use anything that changes them in a dramatic way. But VSCO filters come with a sliding scale so that you can pump a filter's intensity up or down. I use one specific VSCO filter on a very low intensity for some of my pictures so that my grid has a uniform aesthetic (I like my feed to have a certain vibe, despite all of the different subjects that live on it). Another cool thing about VSCO is that it has its own Grid feature, which gives you a testing space and lets you plan out your Instagram grid before you hit Publish.

4

INSTAGRAM'S EDITING TOOLS

Instagram keeps getting more sophisticated in its own in-app editing capabilities, which you can access by tapping on the wrench icon once you've selected a photo to post. It has similar brightening, saturation, and contrast tools to those in Snapseed—so at times, when a raw photo is nearly post ready, you can skip Snapseed and Facetune altogether and head directly here. My favorite editing gizmo within Instagram is the Adjust tool, which lets you level outlines and get a perfectly straight photo. Within Adjust is a proportion function, another favorite for fixing anything that happens to look like I took the shot in a fun-house mirror.

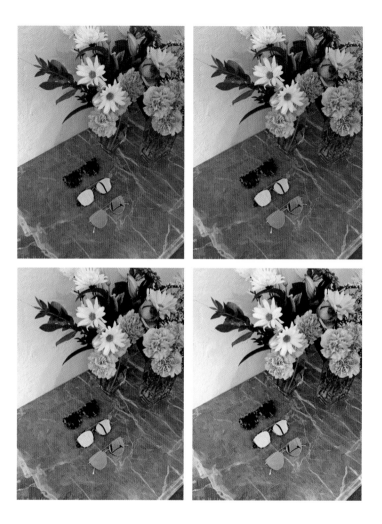

1 2
3 4

1　The original photo was taken at night under incandescent lighting, which makes this image a bit yellow and too warm.

2　Using Snapseed, I brightened the photo, brought down the warmth, and gave it more contrast.

3　Using Facetune's Details feature, I sharpened just the sunglasses.

4　I applied a light VSCO filter and posted this image onto Instagram.

1 2
3 4

1 The original photo that was taken by my assistant at my jobsite. Note the random coffee cup (not mine) on the left.

2 Using Facetune's Patch feature, I made the coffee cup disappear.

3 Using Snapseed, I made the photo brighter and less warm and cropped the image.

4 I sharpened the image using Instagram's sharpening tool and posted it.

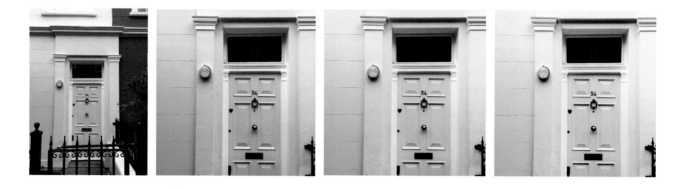

1 The original photo I took in London on a gloomy gray day didn't highlight the pretty pink door on this town house.

2 Using Snapseed's Transform feature, I straightened the image so all the lines are more aligned. I also brightened it and gave more contrast to the photo so the colors pop.

3 Using VSCO Cam, I found a filter that added a pink overlay to the photo, which resembled how the door and building looked in person.

4 I sharpened the image on Instagram and posted the final version.

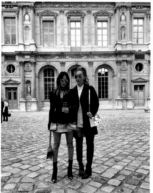
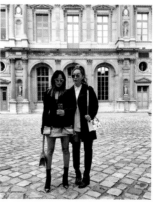

1 The original, unedited photo.

2 Using Snapseed, I brightened the overall image, then selected certain parts of the background to brighten while leaving our skin untouched.

3 I added a VSCO Cam filter and then posted onto Instagram.

Et voilà! Postproduction editing might seem like a lot of work, but you've already taken the time to style and compose a cool shot, so why not put in the extra effort to fine-tune it to pro status?

A word on shadows. When it comes to an Instagram shot, the word *shadow* can be dirty. You don't want a shadow covering your face or darkening the bagel-and-lox plate that should otherwise be brightening your brunch. There are times when shadows are menacing—for example, if someone is standing near you during a daylight shoot and you can see their shadow but not them (photobomb fail), or if you're standing in direct sunlight and your nose is casting a beak over your face.

However, when used correctly, shadows are actually a great way to get artsy with a shot and help contextualize a post's time of day (cereal and morning sun, anyone?).

Interesting shadows can be created by blinds and window coverings (think sunlight flooding into a bedroom through horizontal blinds), patterns from light that shines through tree leaves (those lucky enough to live in a warm climate will find killer patterns in palm-tree leaves, in particular), and even the way that the sun's rays might hit your shoes or pants.

As with so many elements in photography, there isn't a right or wrong way to deal with shadows—you have to experiment and have fun with your shots and look at potentially weird lighting situations as an opportunity to get creative.

Outfit Shots and Selfies:
Perfecting Them Both

Instagram is both organic and curated at the same time. While I always try to show real, inspiring moments throughout my daily life, I want to capture them in the best possible way, which means thinking about what I'm putting out there and planning in advance. Every single day comes with at least one outfit post (and that's when things are slow).

After much trial and error, I have perfected the art of the outfit shot (shoe close-ups, arm swag, and necklace selfies included—mastering the accessory pic is key; people want to see as much detail as possible). What I wear has become another way to tell my story, expressing my mood, my agenda for the day, and where I am in the world. I always make sure there's harmony (or deliberate contrast) between my outfit and landscape. It's all part of taking everyone on a journey with me.

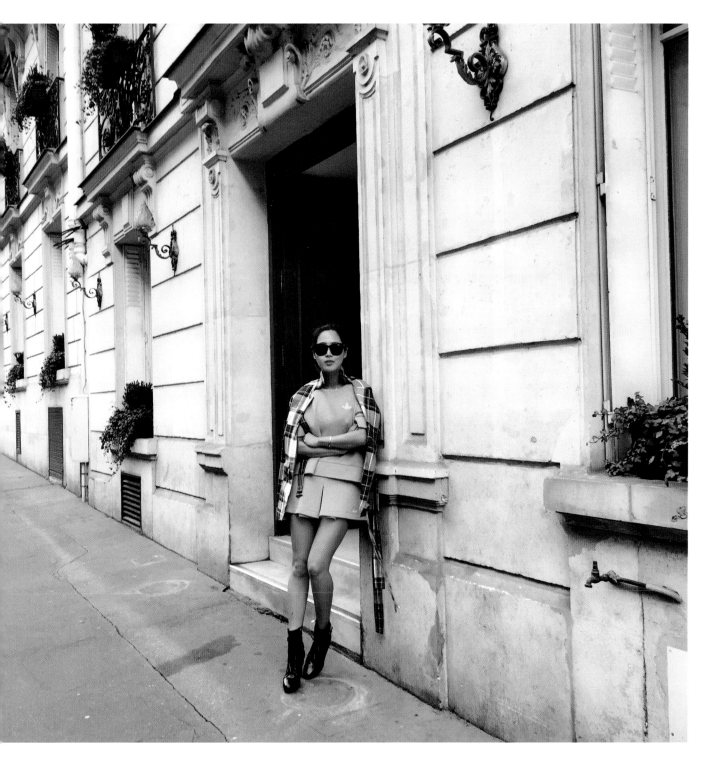

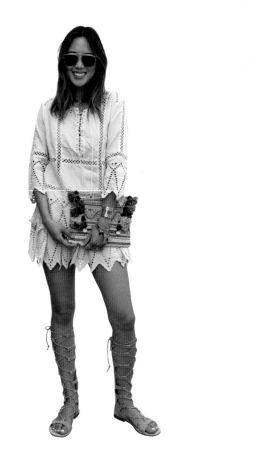

COACHELLA

L.A.

Coachella calls for boho-infused pieces befitting a laid-back but stylish music fest.

Dressed-up denim for meetings in L.A.

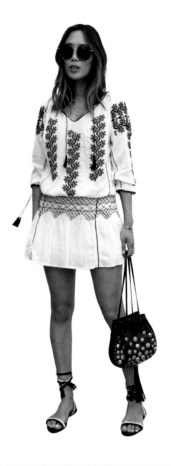

PARIS

Nothing says Paris romance better than a beautiful dress.

MEXICO

Casual, light tribal dresses and simple sandals are comfy enough for sightseeing and perfectly blend into Mexico's surroundings.

This section is dedicated to personal style. Remember, it's not just what you wear, but how and where you wear it.

Here, you'll learn:

- The difference between an outfit photo and a selfie, and how to choose between the two.

- Major Herb Ritts lighting tips for selfies.

- How to get the Karlie Kloss legs-for-days look in an outfit shot.

- When you should invest in a selfie stick (I admit, it's actually worth having for the right moment).

- Tips on how to work your style with your surroundings (e.g., which backgrounds warrant an adorable sundress and a smile and which ones require something edgier).

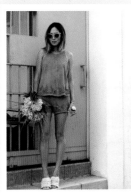
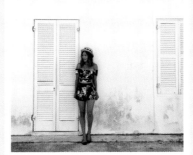

Social Media:
Your Style Showcase

I still remember the first outfit photo I ever took. It was November 2008. I was in design school in San Francisco and heard about a job opportunity at the San Francisco Design Center, a huge two-building complex with dozens of luxe furniture showrooms and architectural firms—aka heaven. I didn't have a ton of money at the time (hence the need for the job), but I did have an idea for how I wanted to present myself at the interview. So I belted an oversize green and black tunic from Forever 21 and wore it as a dress with a pair of black Steve Madden platform heels, which reminded me of a similar pair by Burberry.

I probably spent $75 on my look, but I felt invincible and stood out among my fellow applicants—a sea of black blazers, business-casual trousers, and ballet flats (even the handful of guys vying for the position wore stodgy suits). I must have done something right, because I got the job. I loved my interview look so much that I went home to my four-hundred-square-foot studio apartment (complete with a scenic parking-lot view and a swath of harsh yellow light), documented the ensemble, and published my very first outfit post on *Song of Style*. Little did I know that my life would change all because of that Forever 21 tunic.

By the time I started my Instagram habit in 2011, I had grown my following by documenting my life and engaging readers. On my blog, I found that readers loved to get more deeply into what I was up to—from tips on how I styled my favorite white summer jeans to posts about the travels I was lucky enough to experience for work. With

Instagram, I could pull out daily details of the bigger blog-worthy moments to showcase, including the hidden alleyways (and ice cream parlors) of Florence, Italy, flea markets in New York City, and the pocket detailing of those crisp white jeans. That these elements of my life directly influenced and helped build my career (and vice versa), is like #whoa.

While my blog was totally morphing from mere outfit photos into a full-fledged visual lifestyle journey, I still wasn't sharing some of the more personal (and important) sides of my world: my younger sister, Dani (though I obviously called out the times I borrowed her clothes), or my dog, Charcoal. I left the contents of my breakfast table and the details of design meetings on construction sites largely out of the picture.

Instagram, on the other hand, provided a platform to share the camera-ready things I didn't put on the blog, which was much more curated and editorial (that's not to say that Insta isn't curated; it is, but it's not as precious, so to speak).

Now Instagram is my home for the times I'm on the festival fields of Coachella or simply eating a gorgeous acai bowl at my favorite L.A. café. If the blog is a methodically planned film production, Insta is the fun little BTS (behind-the-scenes) moments that are just as fun to look at as the movie itself.

I realize that outfit photos aren't everyone's cup of perfectly grammed tea. But if you're into fashion like I am, or you happen to be looking for a career in the industry, showcasing your personality through your self-ripped jeans and rows of arm swag is never a bad idea. And because the Instagram community is so strong, the platform is the ideal place to show off your stellar styling and photographic skills to anyone who happens to find your feed—the fashion designer you're dying to work for, the tastemaker whose blog you read on the reg, and/or the hiring manager of your favorite denim brand. Think of it as a modern-day portfolio that showcases your sensibility, skill set, and overall vibe.

#OOTD *Arsenal*

THE DRESS

Something cute and casual, with an effortless vibe, that still makes you feel special.

THE SHOES

Extra points for statement stilettos, dope sneakers, or a pair of pumps that exude sophistication and boss-lady mentality.

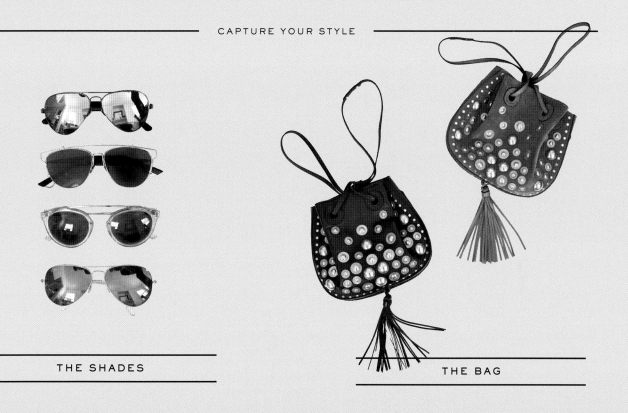

THE SHADES

Because nothing makes an outfit photo more badass than a pair of sick sunnies.

THE BAG

Luggage, cross-body, tote, or clutch, a good bag is the cherry atop your #OOTD sundae.

THE ARM SWAG

No #OOTD is complete without a wristful of bracelets and, if possible, a really cool watch.

#OOTD *Drills*

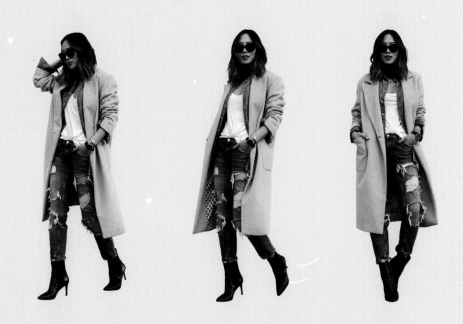

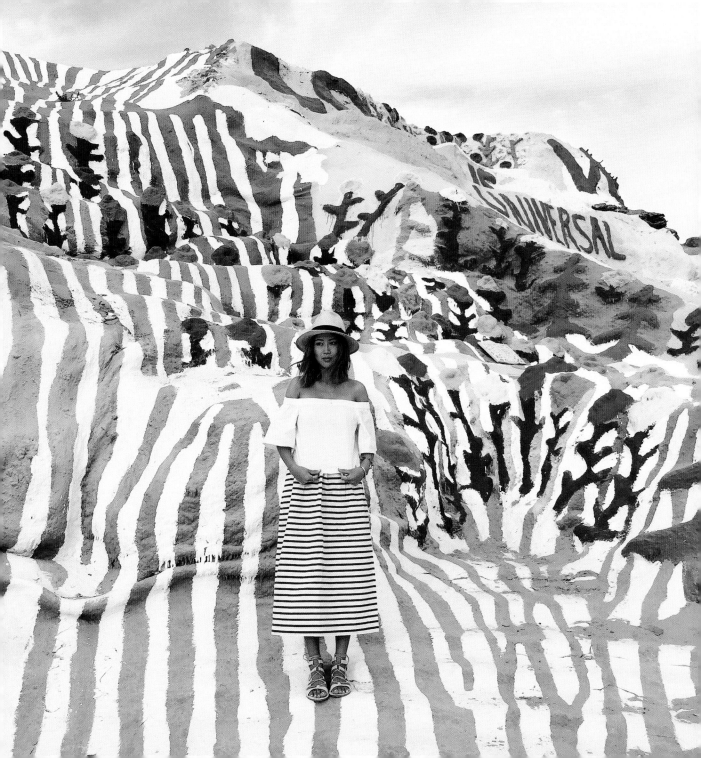

Like every moment on Insta, your goal here is to tell an inspired, authentic story. Imagine the outfit as the main character and display its role in your daily life.

When it comes to picking something to wear, everyone's opinion is different, and there really is no right or wrong thing, as long as you wear something you feel really good in (confidence comes out in the picture, I promise). Ultimately, it's all about the execution of the photo, the harmony between your look and the background, and how it flows in your grid.

Cue the Location

Last May, I went to the Cannes Film Festival in the South of France (#blessed). Before I left, I did my homework and discovered that my hotel, the historic Hôtel du Cap-Eden-Roc (coincidentally, one of Grace Kelly's former hangouts), was right against the ridiculously blue water of the French Riviera. As I packed, I *reeeeeally* took my impending posts into consideration. I asked myself what I could convey through my clothes in such a cinematic atmosphere. I landed on the vision of an old-school movie star meets modern Parisian dream—one part *To Catch a Thief*, one part Audrey Tautou sashaying down the Croisette. Like a French actress, I wanted effortless chic—classic and simple—all the while still turning heads. After trying on a rackful of gowns (I know, I'm rolling my eyes at myself, too) along with basically everything else I owned, I settled on a long, strapless,

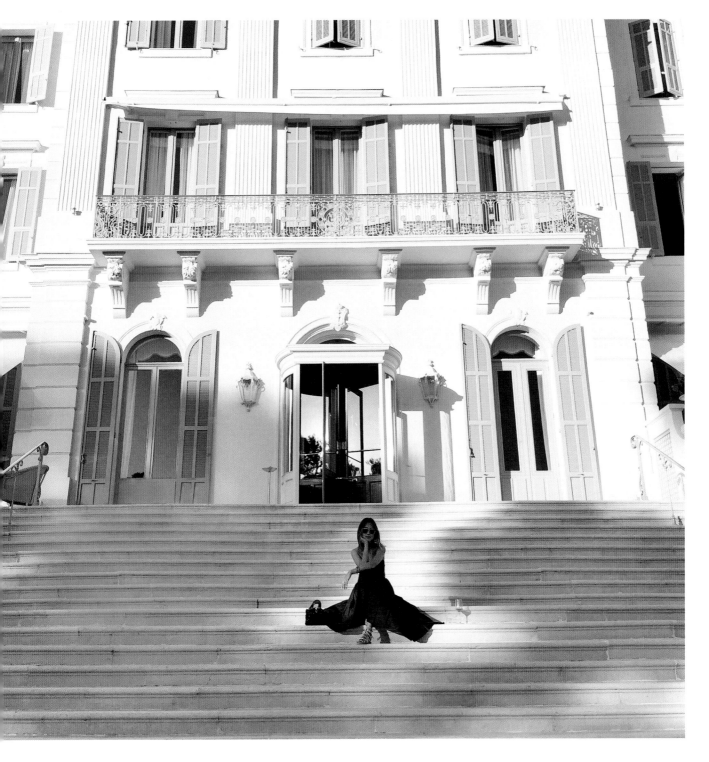

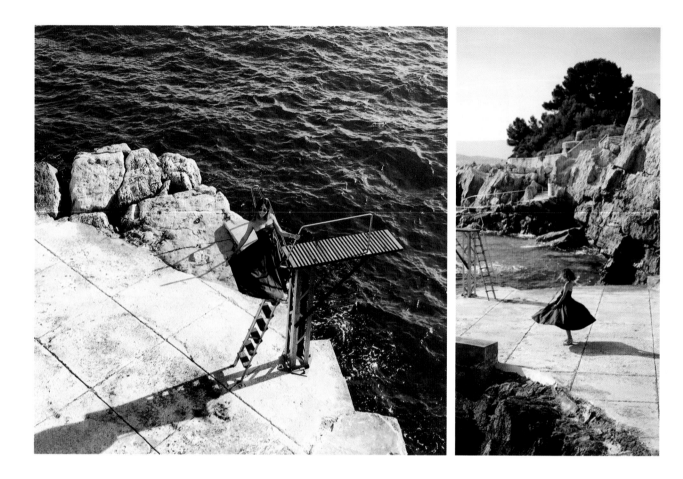

LEFT On the Riviera. Imagine diving off that board . . .

RIGHT We played around with different angles and action shots to capture the billowing dress (it was hard to choose a favorite, but this one made the cut).

black Tibi dress that felt modern and romantic, much like the film festival itself. The minute I had downtime in Cannes, I borrowed a page from the Jane Birkin bible and paired the dress with flat sandals for a casually cool vibe—the opposite of the obvious heel choice, which is what got me excited (coincidentally, the same year, there was a ban on flats on the red carpet!). I grabbed my sister, Dani, to play photog, and it was on.

We walked the perimeter of the hotel's property, stumbling upon a grand outdoor staircase set in front of an ornate wrought-iron terrace and three dramatic sets of French doors. I sat on the stairs and draped the fabric of my dress over some steps. To get in the mood, I imagined I was about to debut my own silver-screen moment.

In the periphery, I spotted a diving board jutting over the riviera. I! Had! To! Shoot! It! I sent Dani to a landing above the board (NEVER be afraid to direct your photographer; more on that later). She was even willing to get on the ground, to get the whole scene into play (another thing your photographer can't be afraid of—getting down and dirty). Diving board? Check. Dress volume? Check. Deep-blue water? Check. Massive rocks? Check. The whole scene came alive and felt oh so South of France. Had I been in denim cutoffs or even a basic day dress, the photo would not have been nearly as epic. The situation called for glamour, and I brought it.

Do you have to fly to exotic places and pack ball gowns to accomplish the same goal? Hell no. I accomplish the same vibe sitting on my couch, as long as I'm dressing for a story. No matter where you are or what you're wearing, pay attention to your clothes and your surroundings and think about whether or not they make an interesting narrative.

My point is: If you're going away, even on a weekend road trip, it's definitely an excuse for overpacking. Sometimes it's fun to get into character and create a fantasy. Take a risk, if it will make a photo better. Bring things that you know will work in an outfit shot. Mix up your surroundings and your threads. Wear elevated formal on

a casual beach (because YOLO) and jeans in a formal ballroom. Good juxtapositions often go a long way on the "like" train.

If I'm riding my bike in my L.A. neighborhood, which is full of white picket fences and charming old homes, I'll wear a feminine, frilly sundress and flats to capture that easygoing spirit. If I'm hosting a pool party with a brand at, say, a Spanish-style ranch in Malibu, I'll choose a bathing suit that reminds me of quintessential California (a one-piece stamped with a palm-tree print versus a mesh cutout bikini that might be better suited for a pool party in Vegas). Whether I'm going to a glam spot like Cannes or a restaurant around the corner, I *always* think about the vibe of my location and what the outfit photo to match will be.

One of my last trips to Italy offers a really good example (Italy happens to be one of my favorite places on earth, if only for the hazelnut gelato). Last June, I spent time along the coast in the towns that make up Cinque Terre (aka five

lands), and my outfit shots consisted of simple silk slip dresses and flat sandals, printed palazzo pants that make every step feel like you're traveling with a Beyoncé wind machine, and androgynous T-shirts and short-sleeved shirtdresses that didn't require much thought. The casual, relaxed looks were cute enough to warrant outfit posts but, much like Cinque Terre itself, never felt like they were trying when they were set against beautiful flower boxes, terra-cotta buildings, and the area's trademark striped beach umbrellas that look right at home next to the blue waters of the Tyrrhenian Sea. My research on the places I was going and the photos I could take there dictated what went into my suitcase.

A smart strategy for outfit shots is to imagine that you're costume-designing a scene in a movie or styling an editorial photo shoot for your favorite magazine, minus the assistant and wardrobe trailer (though these things help, I assume). That is the essence of a cool story, and your caption should follow suit.

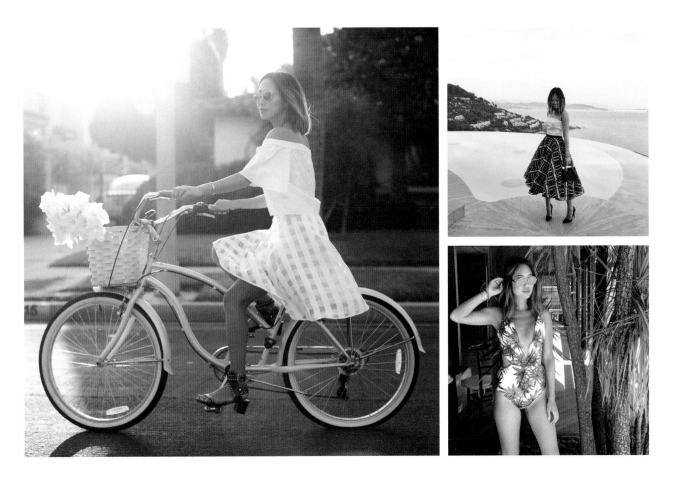

1 2
3

1 Keeping things light and
flowy in L.A.

2 Having a Dior moment
in Cannes.

3 Palm prints and cutouts
in Malibu.

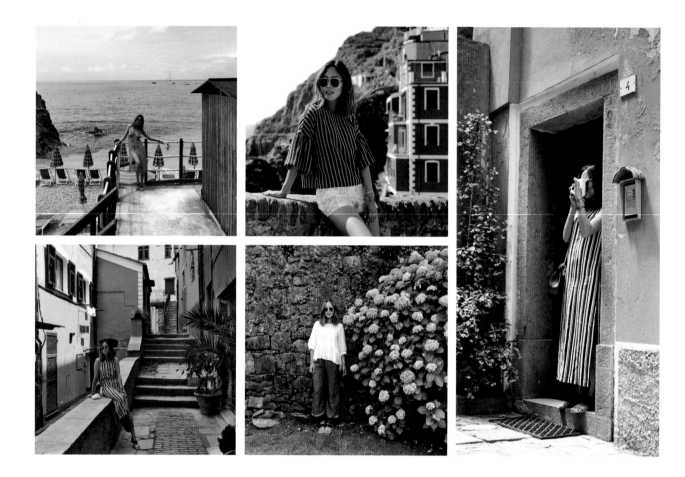

1 2 3
4 5

1 When I visited Cinque Terre, a string of colorful towns along the Italian Riviera, I didn't pack anything black. Using Snapseed's Selective Adjust tool, I brought out the vibrancy of objects in the background.

2 Posing against a red brick wall and the incredible cliffside.

3 A candid meta-moment my boyfriend happened to capture while I was busy taking a Polaroid.

4 A great example of how a shadow can add focus to unexpected aspects of a photo.

5 Hydrangeas acting as a perfect backdrop.

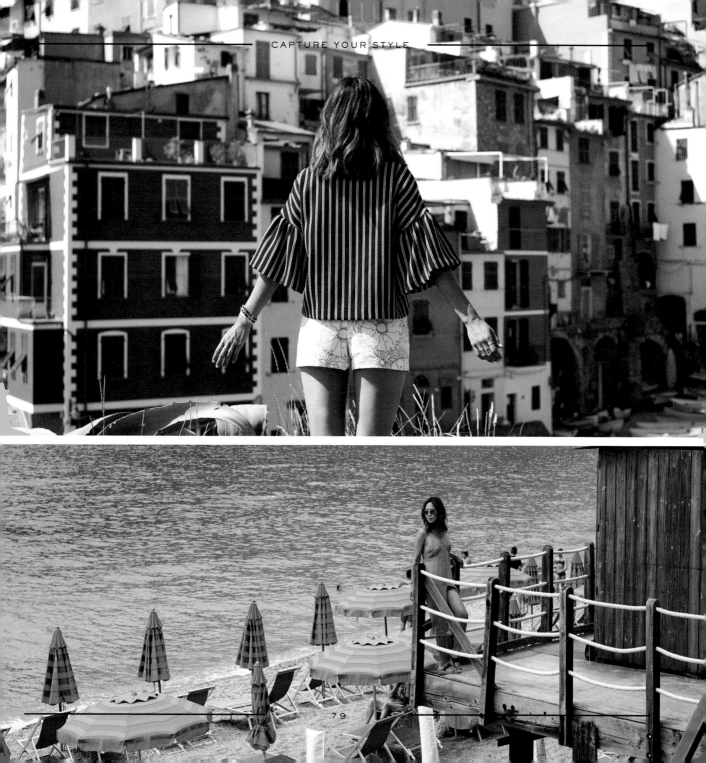

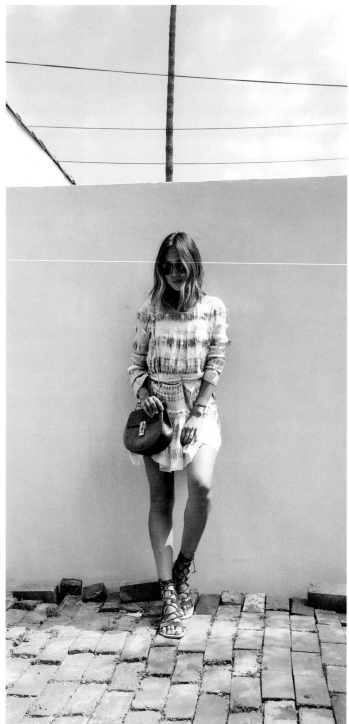
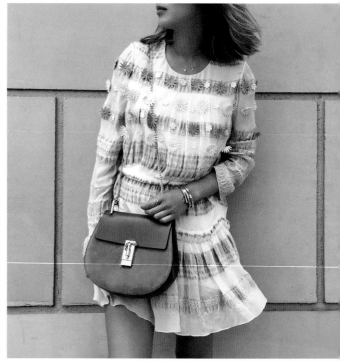
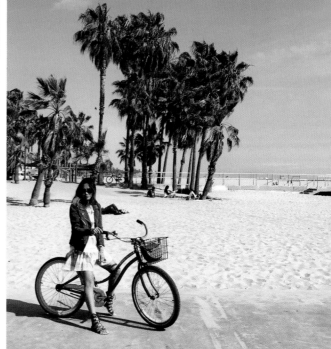

Outfit Orientation

I've talked about location dictating outfit. Sometimes I have the outfit in mind before the location. If that's the case for you, location scout. Think about the kind of background that would complement your outfit, and then find the perfect setting, like your own little scavenger hunt. I actually have a list of amazing blocks, corners, parks, and such that I've found along the way so that, when I do have the right look, I know where to go.

I was completely obsessed with Chloé's spring 2015 collection. There was a major white and beige striped dress with a floral appliqué that I wore on a warm Sunday in L.A., and while I was enjoying my free day with my sister, I wanted to shoot this dress for my Instagram. Since the dress was a neutral, earth-tone palette, I approached my shot of it like designing a room, trying to find the best balance. I didn't think a place with busy and loud colors would work—it would compete with the dress. I needed a bohemian, kind of seventies vibe that was right from the book of Talitha Getty. Laurel Canyon luxe was exactly what the dress demanded. It's muted. It's understated. It's full of nature. On my way to go bike riding in Venice with my sister, I came across a light terra-cotta wall with horizontal lines just like those in my dress. A few blocks away, there was another blank, beige-hued wall that happened to have exposed brick, which I originally did not think would work. But the brickwork was rustic, a bit dilapidated, and beautifully faded. Both areas perfectly matched the fluid draping of the Chloé number, in their own way. And just like that, photos were born.

The moral of the story is this: You can put the outfit before the location or the location before the outfit; just make sure they look good together.

The Action

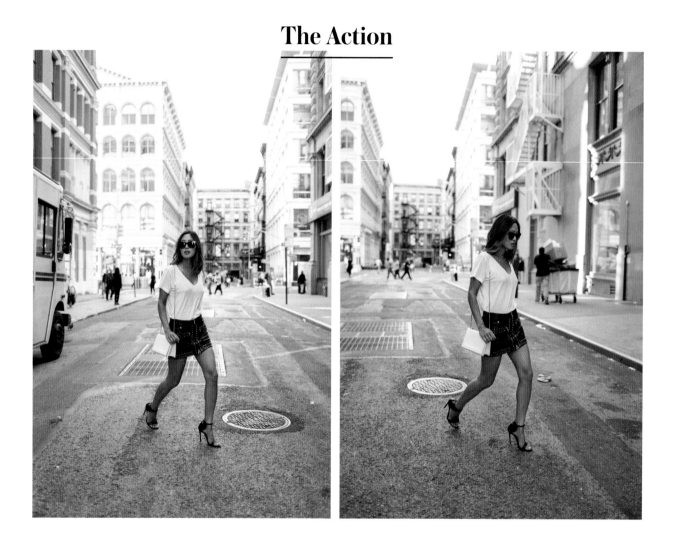

Just because you're taking an outfit photo doesn't mean that you have to stand motionless. There are so many ways you can move to show off your clothes in a creative way: sitting on a bike, lounging in a gorgeous chair, crossing a street, bending down to fix a sandal strap, dancing in front of an airport terminal (you get the idea). Let your outfit determine whether you're in action or not. Will it move well as the wind blows? Is it structured and stiff? Go with what will give you the best result.

If I'm stepping off a curb in a photo, I generally like to show off a really great shoe—extra points for anything lace-up, stiletto, or with cool detail. As for jumping, it's best while wearing something that's easy to move in (definitely not stilettos)— like a T-shirt and workout pants or an oversize shift dress. I can't lie—I like to do a little dance in my photos (what can I say, I get excited!), and it's always helpful to wear an outfit that's meant to be in motion (think fringe details, accordion pleats, bat-wing sleeves). For walking shots, show off those legs. For me, that means a short skirt or shorts (just make sure you never Britney Spears/commando it). Jeans also make a great walking-shot subject and show off the legs in a different way, as does a long dress with a slick slit up the side.

The Occasion

As I mentioned at the start of this chapter, outfit photos are my jam (if you're already getting dressed for the day, why not take a photo of it?). There is no occasion when I won't take one (unless I actually don't like what I'm wearing). That's not to say my followers don't respond to certain outfit shots better than others. My most popular outfit shot to date (more than fifty-seven thousand likes!) was when I stood in front of a clean brick wall wearing a lacy red dress by the British brand Self-Portrait, all while eating a cup of froyo. I was sporting sunglasses and a Chloé bag (people love their accessories). To be honest, I didn't put a ton of thought into the photo—I just happened to be wearing a dress I really liked and some cool accessories, and really had a craving for froyo (as I usually do). But the story the photo told was just simple enough to be relatable to my followers, who, I like to believe, follow me because they know I unapologetically eat dairy (and many, many carbs) in public. You don't have to tell an elaborate story to create a successful outfit post. Just weave an outfit that makes you feel good into a small part of your actual daily life (e.g., getting ice cream, dropping off a package at the post office, meeting a friend for lunch) and you're much more likely to inspire your followers by being real.

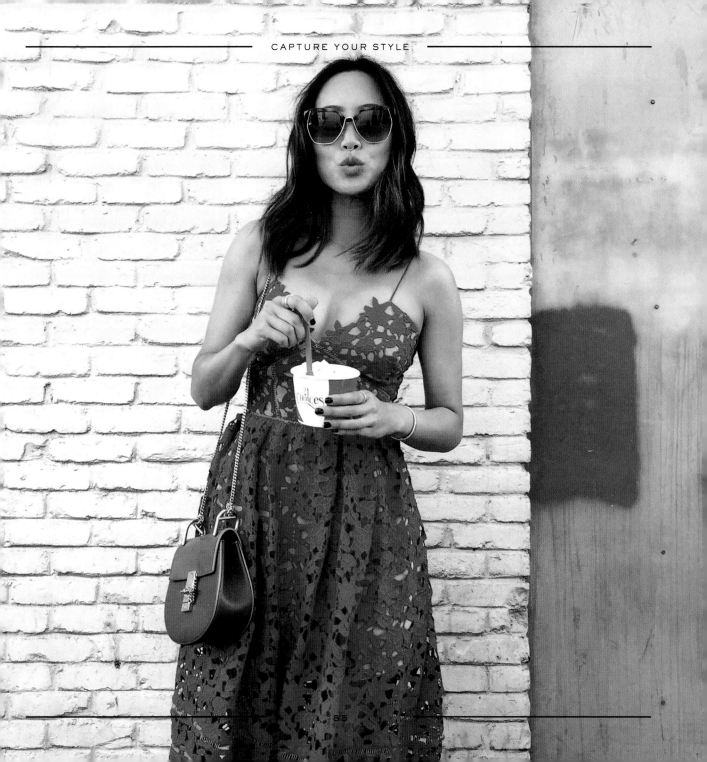

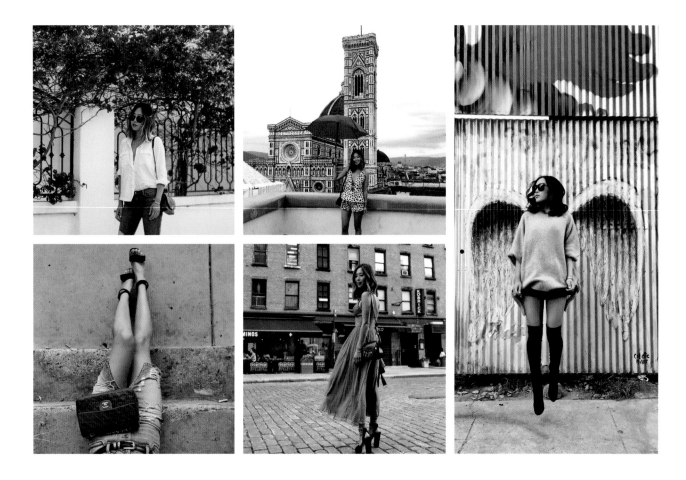

1 2 3
4 5

1 This simple outfit would have been so boring in front of a plain wall, but the florals provide a frame and add much-needed color.

2 In Florence in front of the Duomo. I sharpened the details using Facetune, and the umbrella adds a nice break in the composition with its vibrant red hue.

3 I had my photographer set his camera on burst mode so I looked like I was flying with this L.A. street art. Out of thirty photos, only three weren't blurry.

4 Nobody was around, so I just sat on somebody's doorstep and took this photo. My purse is another example of how one bright color adds visual interest.

5 After going to a runway show during New York Fashion Week, I wanted to capture my flowy dress in the wind. Orange totally works against the muted cobblestones.

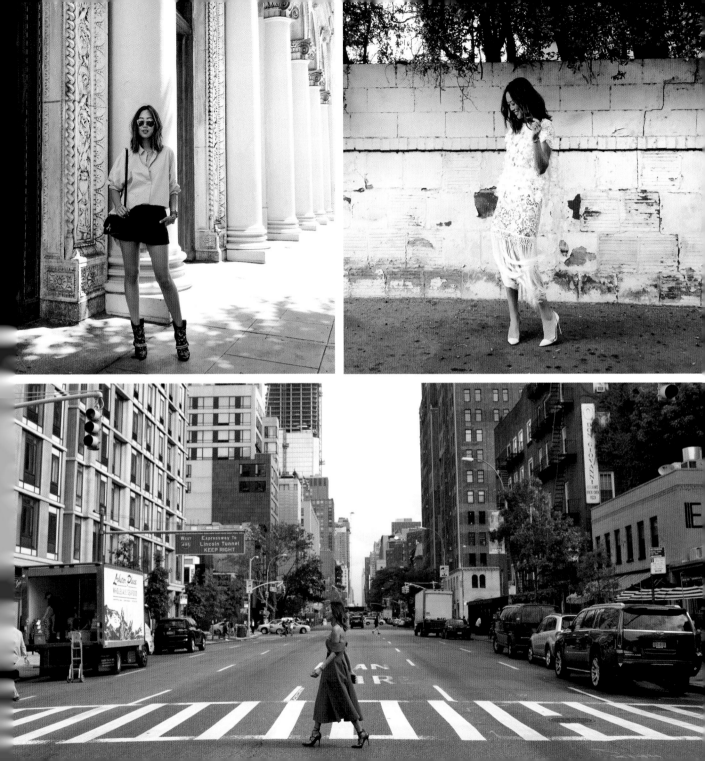

The Details

There's no rule that says every outfit shot has to be a head-to-toe look. Often, your arm swag, bag, shoes, or even the detail on a pair of pants can be the real stars of the show. So don't be afraid to capture and post just one aspect of your overall look. The same basic rules of good photography apply when taking a detail shot: stay in focus (tap that screen), natural lighting (get that sun), harmonious background (duh). There's no right or wrong way to frame the shot, so put your phone's camera grid feature on and play around. Start with the main photo subject in the center of the screen and then move it slightly off to a side, a corner—even so much that it feels a little abstract. Then decide which you like best and what would work on your feed. If the previous shot is a shoe, go with the arm swag or even that amazing nail-art mani you wish you could hang on your wall

(an Instagram is basically the same as hanging a painting over the mantel, no?).

If you want to shoot your shoes, you can sit down and stick your legs out (straight or both bent to one side). Foot candy! Just make sure your pedi is up to par if you've got an open-toe situation. Another good way to take a shoe shot is to stand and stick your butt out, pressing Snap from a bird's-eye view. To show off an armful of bracelets or a sick watch, try incorporating your shot into a still life with, say, your morning cappuccino, decorative tabletop décor, on top of a graphic scarf, or next to a stack of magazines.

The coffee cup is an Insta staple. (It's also an unavoidable Insta cliché, but for now get your caffeine on, and I'll get into that later.) Hold the mug with the arm you want to feature to get a more interesting image (mani better be good, too). You

1 2 3
 4 5

1 Trying to take the perfect shoe shot because #ihavethisthingwithfloors. The best way to do this is to stick your butt out and, while using your grid feature, make sure the tiles are aligned and not distorted.

2 + 3 Different ways to capture a coffee shot (solo and with a photographer).

4 The harsh overhead lighting brought out cool shadows to enhance this coffee shot (the Chloé bag didn't hurt, either).

5 Latte art, though sometimes cliché, is one of my favorite shots. How do they even do that??

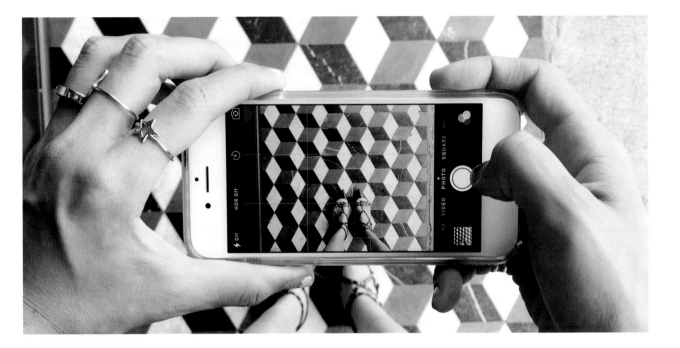

ABOVE Making sure my lines are straight to capture that perfectly aligned tile shot.

can also capture a clutch and sunglasses by incorporating them into your morning-coffee shot (like Chanel, coffee goes with everything). Holding the camera directly above the subject from a bird's-eye view is best for this type of shot. Have a shoulder bag? Ask your photographer to zoom in and get your shoulder to your midcalf, which will highlight your purse and add nice variation to the full-length outfit images so typical of Insta feeds.

There's no rule that says every outfit shot has to be a head-to-toe look.

The Photographer

Perhaps more important than having a sick outfit or a gorgeous background is actually having someone around to document it all. And, unlike selfies, an outfit photo most definitely does not have to be taken by you exclusively.

I happen to be the kind of person who doesn't mind harassing strangers on the street, especially if an outfit photo is on the line. So I will ask anyone, anywhere, to take my picture if I'm alone and in need of a shot. I've worked with security guards, tourists, mailmen, doormen, construction workers, makeup artists, waitresses, and valets. I can go on. I'm not joking.

Ready to give it a go yourself? Here's a sample script:

You: Excuse me, do you mind taking a photo of me? I promise, I'll be quick.

Them: Sure. [Here's the part where you make sure they take the photo with your phone and not theirs, which would be weird.]

You: Please kneel down and hold the camera like *this*. [Once your new friend is on his or her knees, kindly angle the phone slightly up while it's in their hand. Even better: Frame the photo for them so they know exactly how to take the shot. Showing them a photo of what you want the background to look like doesn't hurt, either, so try to take a test shot on your own sans subject before your photographer gets started.]

[Before your shutterbug hits Snap, stand in position and ask for a test shot. Then look at the camera

```
to make sure the lighting and angle
looks good. Adjust accordingly.]

You: [Assume your position.] I'm
ready! [Snap, snap, snap.] Do you
mind trying one vertically now?

Them: Sure. [Snap.]

You: Can you try one more with
the camera a little to the left?
[Snap.]
```

This is the part where you should go and take a look at your new friend's handiwork. Once you've found a shot that works, thank your photographer and be on your way.

Of course, you can always ask a friend, neighbor, coworker, or someone else you actually hang out with. Regardless of who takes your outfit photo, you can't be afraid to art-direct the shot and tell your lensperson exactly what you need for the perfect image. If your photographer is standing and the camera is angled down, you're going to look shorter. I find it's best to get someone to kneel and take the shot with the camera angled up, giving you a long, lean, Karlie Kloss leg effect. (No friends in sight and feeling too creepy to ask a stranger? Just think of the cute story this could make for your grandkids if your random photographer ends up being "the one.") Always ask for a few shots for good measure. Options are vital.

There are indeed other ways to get your shot without feeling humiliated. Tripods are cheap (think $40, max) and can be set up to work with your camera's timer. If you don't have one and can't miss a good moment, balance your phone on books with some paperweights to hold it straight and go the self-timer route.

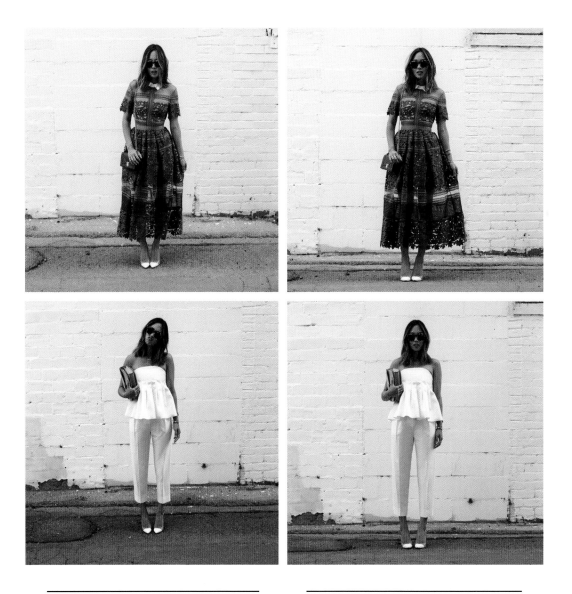

SHOT ANGLED DOWN

SHOT ANGLED UP

#OOTD Recap

01 **Showcase your true style.** Traditionally ugly or not, there's no such thing as a "wrong" outfit as long as you're authentic.

02 **Make sure your background and your outfit are in sync.** Wearing a busy, colorful, patterned dress? Keep the background simple. And vice versa.

03 **It's all in the details.** If you're not into posting your head-to-toe look, get creative with highlighting a watch, shoes, or other accessory.

04 **Angle is key.** Just like with your selfies, play with angles to see what you think looks best. In general, full-body shots taken while kneeling with the camera angled slightly upward are preferred for their magical ability to act like an instant diet/supermodel-leg machine, while taking a photo with the camera angled down will make you look squat. The camera only adds ten pounds if you use it wrong.

05 **Make sure your photo is clear, sharp, and focused.** Just like with your selfies, make sure your camera is in focus by tapping your screen until you see a clear image in the frame. Take as many photos as needed until you have one doesn't look like drunk goggles.

06 **Lighting makes—or breaks—a photo.** Your followers deserve to actually see what you're wearing, so try to take your outfit photo outside or in a room with plenty of natural light. Tap on the lightest and darkest parts of your screen to change the amount of light your lens lets in. Keep in mind that it's easy to lighten up a slightly dark photo with editing apps, but once an image is too bright and blown out, it's beyond repair. Find good light balance and experiment until you get the shot you want.

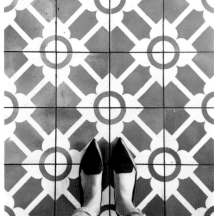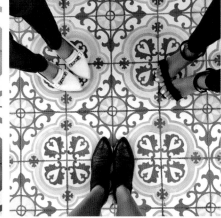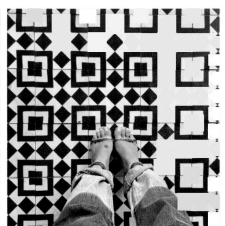
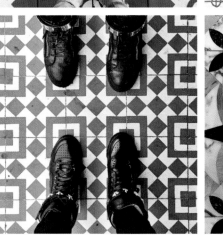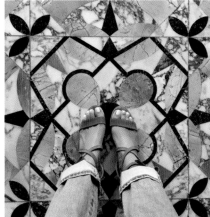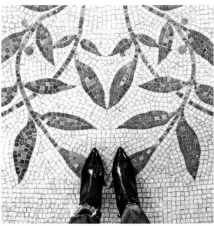
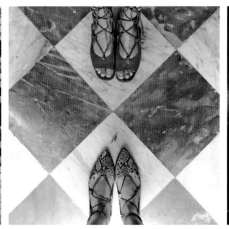

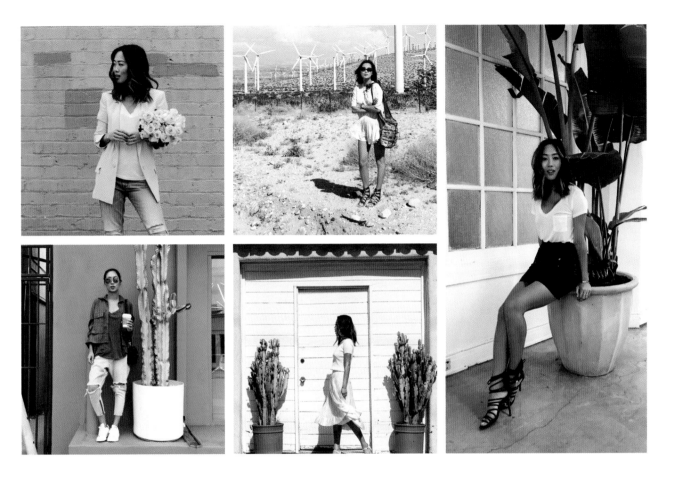

Killer footware + cool tiles = Instagold.

Some of my most loved OOTD shots.

07 **Think about geometry.** Imagine an invisible grid around your photo and all lines—horizontal and vertical—are straight, or, better yet, use your phone's camera grid feature. You can also perfect an image in postpro with the vertical and horizontal Perspective Correction tool on Insta.

#SelfieSchool

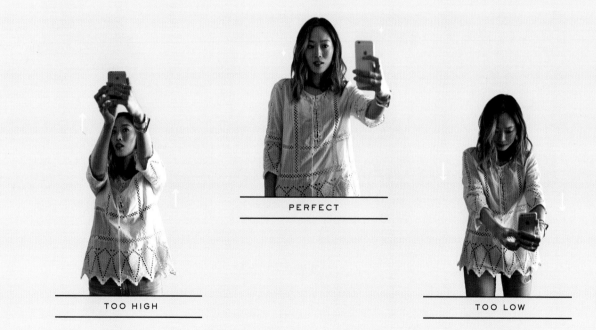

TOO HIGH

PERFECT

TOO LOW

The Selfie

Selfies tend to get a bad rap (despite what Kim Kardashian might say), and, truth be told, I'm not the biggest fan. I rarely take them, because I don't want to bore people with pictures of me making faces in my bathroom mirror. But that's not to say that there isn't a time and a place for such things. Selfies can actually tell cool stories when you're alone, rushed, or not in the mood to ask someone to take a photo—during a sentimental visit to your alma mater, sightseeing in a packed crowd in front of the Duomo, or if you stumble upon an interesting building with an unexpected window pattern that creates an amazing contrast to your outfit. Even a night out with friends might call for a solo bathroom-mirror shot while doing your makeup (don't be afraid to scribble a hashtag in lipstick on the mirror). Every Instagram post—selfies included—tells a story of some kind and allows other people to step into your life, just for a moment.

Of course, there are exceptions to the lists on the following pages, so use your best judgment. Remember, even if you remove a post, nothing on the Internet is gone forever, and everything you put forth is a representation of you and your personal brand, even if you're "private." Make sure you deliver the message you really want to have define a part of you. If you're about to snap away, ask yourself if this could be a mortifying moment someone will haunt you with later (like when you cancel a plan, and then the person you bailed on sees that you clearly had a better invitation elsewhere).

Picking a proper time and place for your selfie is only half the battle. Once you feel like you have your game face on and your confidence level is high, there are a few photographic technicalities that will take your gram from amateur hour to Bruce Weber via iPhone.

SITUATIONS WHEN TAKING A SELFIE IS DEFINITELY NOT ONLY ACCEPTABLE BUT *RIGHT*

At a music festival (especially if you're "accidentally" photobombing the band).

In front of the Cinderella castle at any Disney location throughout the world. (In front of any castle, anywhere, for that matter.)

The beach. Extra points for a picturesque background of sand and waves.

Any celebration (graduation party, wedding, black-tie charity function, Cinco de Mayo fiesta, *quinceañero* party, bar mitzvah, Super Bowl soiree, and you get it).

In a car (that is parked and/or being driven by someone else—preferably in the back of an Uber en route to somewhere also befitting a selfie).

On a ski lift (or any leisure craft high above the ground).

On a boat (because, obviously).

Standing next to a celebrity who causes you to completely geek out (Pharrell and Beyoncé, this means you).

On an airplane (preferably jet-setting somewhere that causes excitement to shine through your face; but no more boring wings-in-the-sky posts, unless a yeti is standing out there waving at you).

Somewhere too gorgeous for words (mountaintop, post-hike; surrounded by 360 degrees of mirrors, for the boundless effect; an infinity pool; a beautifully designed room; etc.).

SITUATIONS WHEN TAKING A SELFIE IS *NOT* ACCEPTABLE

While in the exam room during a doctor's appointment.

While driving (see item five on page 103).

Any sad family gathering.

In the middle of a religious service or ceremony.

While doing anything in a bathroom other than looking in the mirror (and if you *are* in front of the mirror, remember that the iCloud sees and stores all).

The Lighting

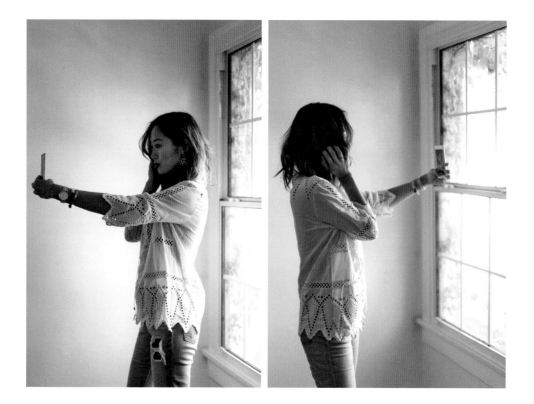

As a rule of thumb, bright, natural light makes for the best photo of your face, so try to get yourself outside or by a window where sunbeams flood in. The golden hour—that time just after sunrise and also just before sunset—makes everything look dreamy and magical, especially if there are a few rays of light dancing across your face. Time your selfies accordingly. If you're outside, pay attention to the shadowy menaces that can photobomb your pic, and position your body so that everything is really clean (unless, of course, the shadow created is artful, enhancing the shot).

Indoors? See aforementioned light-drenched window. To highlight your look, face the sunlight—it brings out the color of your hair and eyes and may capture the sparkle of an accessory or two. But if you're going for a more sultry, softer, almost hazy glow, stand with the light source behind you so that you're backlit. It makes for a moody *Vogue*-ness.

No great big windows with floods of natural light? No problem. LED lightbulbs can be purchased in "warm" varieties that mimic the outdoors (while other kinds of lighting give that cold, gray, doctor's office look you do not want to portray). Much like the nutritional info on food labels, LED bulb packaging features a sliding scale of light appearance, from warm to cool. Warm is where you want to go, so look for bulbs that are three thousand kelvins or fewer to best mimic the golden hour if you're planning a lighting scheme that works well in photos.

Whether inside or out, play with the amount of light your camera lens is capturing by tapping on the darkest and then the lightest parts of your screen when your shot is set up. Each gives a different effect. Take a photo both ways to see which one appeals to you. Don't worry if it's a bit too dark—it can be edited with the right app and in Instagram. If it's too bright, they're harder to improve. I suggest deleting immediately.

The Background

I am a background freak. Like a handbag, it totally makes or breaks the image. And in the case of a face photo, it helps set the tone, so always consider what's behind you. Think about complementary texture, pattern, and colors. It might seem fussy, but it's seriously worth the extra ten seconds of thought. I was visiting New York last September and happened to be staying at a hotel with an airy white hallway that was flooded with light. There was a full-length mirror in the hall where I would double-check myself before hopping on the elevator. One day, I decided to take a selfie in it with the building's vintage architectural windows in the background—not to mention the chrome hardware of the hotel room doors and a peek of fresh pink roses that happened to be there, too. Sure, my selfie was the star of the shot, but the background added depth and beauty to the image

and also let me share a simple hallway that, while a seemingly small detail of my trip, seriously made me happy every day. (Remember in the beginning of the book where I advised you to stop and smell the roses? You really should stop and pay attention to—and photograph!—anything that makes you smile.)

If you want to turn your arm into your very own selfie stick (a flock of tourists photobombing other tourists not included), I'm full of ideas. Stand underneath a neon sign or the arch of an ornate doorway. Find an exposed-brick wall, an alleyway full of graffiti, or a room with ornate wallpaper. Flowers, ethereal blue skyscapes, tree-lined streets, and even a stark white wall (like in a gallery) work wonders. Personally, I prefer simple, straightforward backgrounds with a sliver of something interesting showing. It makes

for a cleaner look that's easier on the eye. And, according to studies, a clean, open space tends to perform better in general.

If you choose a mirror to reflect your background, I get it, but please use your best judgment. Mirror selfies are way easier to take, since you can be only a foot in front of a mirror, rather than extending an awkward arm. It's also an opportunity to get more background into your photos. But as we all know, mirror selfies can go very wrong, very fast. If the mirror is really your best option, make sure it's clean to avoid smudges on your photo. And if you're in an intimate setting, remove dirty laundry, dishes, and any eyesore lurking on the floor. Unless you make fun of your mess with a cleverly worded caption.

You should also be mindful of where your phone appears in a mirror selfie. You probably don't want to hide your face with a phone case, so hold your phone slightly off to the side and lined up with the upper part of your chest to capture your face and body without covering anything critical. Experiment until you find a spot that works with what you're trying to show off (sparkling eyes and classic red lips very much included).

1 2 3
4 5

1 I rarely pass up the chance to take a selfie by a pool, especially when said pool is in Croatia (bonus points when a swan is involved).

2 Dani and I: a sisterly Coachella selfie.

3 Matching shades: a selfie must.

4 Pharrell launched his Adidas line in L.A. and Dani and I geeked out hard.

5 This California girl can't resist a selfie when she is surrounded by snow in Switzerland.

6 7

8

6 No photographer? No problem, because you can't go home without an Eiffel Tower selfie.

7 When Dior dresses you, you take a picture in their Paris showroom.

8 A giant ice cream cone usually deserves a selfie.

The Angle

Experiment to find your good side—everyone's is different—by taking a few photos from various angles. But no matter what that angle is, do not—I repeat, DO NOT—take a selfie from underneath your face. It'll give you a double chin faster than a pack of Oreos.

Hold your phone slightly above your sight line (by ten to fifteen degrees) and turn your head forty-five degrees to one side to capture your face's profile and the angles of your bone structure. Unless you have Halle Berry's perfectly symmetrical face, straight-on selfies are usually not the money shot. Again, experimentation is key, so feel free to move and hold your phone higher and lower until you find a picture you love. Oh, while you're posing, clench down with your teeth to bring out your jawline—a supermodel trick of the trade.

The Pose

You'll want to experiment with a few different lip puckers and various expressions to find your strongest angle. Rumor has it that a certain pair of pint-size celebrity fashion twins say the word *prune* to themselves to get that adorable upturn of the mouth. Try a huge smile and then something serious or moody. Play with your eyes—slightly closed lids can be very "bedroom eyes" sexy. While lots of people hate on the duck face (you know, pursed kiss lips), I personally don't see it as a "don't"—unless you don't like how you look making it or insist on the duck face for every photo. The key takeaway: Change up your pose a bit each time you take a selfie, because a single look can get stale real fast.

The Clarity

Blurry selfies are not cute. Just as tapping on the light and dark areas of your phone screen adjusts the brightness of your shot, it also puts your lens into focus. Play with this technique to get the hang of it. Always take a few photos so you have a choice and can find the sharpest, clearest, best one.

The Ratio

If you look at your Instagram feed in grid view, something I talk about a lot, your selfie-to-everything-else ratio should be 1:12. Translation: One of every twelve photos you post can be a selfie. Any more looks a bit *too* narcissistic—even for these purposes. (Exception—if you're a beauty guru and like to take different selfies in different makeup to give your feed diversity.)

The Distance

This is a personal preference, and it varies based on the length of your arms. The best advice I can give: Hold your phone far enough away from your face so that it frames your face, hair, and part of your torso (unless the story you want to tell is about your nostrils and pore size).

The Group Selfie

As Jennifer Lawrence, Ellen DeGeneres, Bradley Cooper, and their A-list crew showed us at the 2014 Oscars, group selfies may be award-worthy. Given my weakness for backgrounds, I try to keep my group selfies (groupies?) to three people—max—so I can still get our surroundings into that perfect square. It isn't always easy to frame all willing parties in the shot. This is where the selfie stick investment comes in. As embarrassing as it is, the selfie stick is a highly effective tool. A non-stick quick trick: Use your phone's timer feature, which will give you a few seconds to hold the camera steady while you put your energy toward looking fierce, instead of immediately pressing Snap.

Don't be hard on your selfies. For every good one, forty-nine others typically don't make the cut. It's a practice, like yoga (#namaste). Do a series of test shots, switching up angles, lighting, and face positions until you find a photo and style that epitomizes your true selfie. It's not crazy to take a ton of pictures of yourself in the mirror before choosing one that's post-worthy (Kim Kardashian claims to take three hundred before picking a winner). Trust.

MY SELFIE COMMANDMENTS, A RECAP

01 **Post them in moderation.** A 1:12 ratio is your golden number.

02 **Make sure the shot is clear.** Tap your screen to focus your lens. Fuzzy duck face is not a good look.

03 **Find your angle.** No two angles look the same, so move in different ways until you find a tilt that captures the best features of your face. Holding your phone slightly above your sight line while moving your head a touch to one side is a good place to start.

04 **Light it up.** You don't want to look too dark, too yellow, or like you aren't eating your kale, so make sure your lighting doesn't suck. Natural light is best. Take your shot outside or, if you absolutely have to be indoors, head for a window. Lamps and/or overhead lighting should emit a soft glow (i.e., your office's overhead fluorescent lighting is not ideal).

05 **Background is everything.** Whether a simple pink wall or a cool set of bricks on a building, think about what's behind your selfie. Mirrors are fine; just pay attention to what's reflected.

06 **Distance.** Depending on arm length or proximity to a selfie stick, hold your phone away from your face at a distance that frames your head along with your hair and partial torso. Too close can be too scary.

Your Turn

I attribute my stellar selfie skills to a ton of trial and error. And I want you to get into the habit of practicing your selfies, too.

The world doesn't need another yellow-hued, blurry picture of someone making a duck face in the rearview mirror, so here's some homework (it's painless, I promise). Follow the steps below to create your very own backlit selfie.

- Make sure you feel good about your face. Oil blot, powder your nose, swipe your lip gloss, or, if you're having an amazing skin day, show off a fresh face. But whatever you do, make sure you feel really good about how you look.

- Find a good source of natural light— either outside with the sun behind you or indoors near a window that also has light coming toward you from behind.

- Flip to your phone's front camera— that's the one that is lower quality than the rear camera but allows you to see what you're shooting on your screen as you go.

- Hold your phone with your arm extended forward and a slight bend in your elbow. Move your phone forward and back, depending on how much of your face and background you want in the shot.

- When you decide on a decent distance for your shot, hold your phone six inches above your head.

- Tilt your phone down at a forty-five-degree angle.

- Start snapping!

- After you feel good about your angle and lighting, switch from your phone's front camera to the higher quality one in back. Make sure your flash is off and start snapping again.

- Now comes the fun part—the postproduction. Open your Snapseed app and import your favorite shot. Using your own subjective judgment, lighten/darken the shot and play with contrast and saturation levels until you feel like your photo looks better than it did when you started. Save your image to your phone.

- Open up your Facetune app. Have any minor blemishes that need zapping? Use the app's Smooth tool with a very light hand—your goal isn't to transform the selfie into an unrecognizable version of yourself, but rather to lightly enhance what your mama gave ya. Save your shot to your phone.

- Next up on the postpro docket is VSCO Cam. Open it up and import your selfie. Once your photo is successfully imported, it will show up on your VSCO grid. Tap your image and then tap the paintbrush-and-wrench icon at the bottom of the screen. Now you'll see VSCO's selection of filters. Not into any of the preloaded ones? Scroll through to the end of the filter selection and you'll find a Shop section that has even more filters to download, ranging in price from free to $6.99.

- Once you find a filter you like, double tap it to open an intensity slider. As I mentioned, I use a super-low intensity to give my photos a very slight, unnoticeable pop. But the choice on how much of a filter you want to use is all yours. When you're happy with your image, save it to your phone.

- Now open up Instagram. Import your postproduced image and crop it as you see fit. If you want to post your homework, go forth. If not, you now know how to create killer selfies that would do a Kardashian proud.

BECOME A
STORYTELLER

118–165

Now that you have a solid understanding of how to compose and edit your images and have mastered the outfit shot and selfie, it's time to think about all the other amazing stuff in your life that you want to share every day.

If you're anything like me, you're into way more than just fashion (even though you might consider a two-hour wait for a Jimmy Choo sample sale perfectly acceptable). There's so much incredible food to capture (and consume), beautiful sunsets to snap (and watch), relaxing pool days to document (and enjoy), and, of course, your nearest-and-dearest squad—all deserving a spot on your grid.

So just how do you decide what to capture and when to post? I'm an advocate of naturally documenting your day in a way that feels inspiring, as well as planning in advance. There's an art to choosing your subjects and presenting them as a narrative, a way that helps show the complete story of your incredibly cool life.

By the end of this chapter, you'll be a pro at the following:

· Apple versus arm swag: how to choose your subjects wisely.

· The best techniques for taking photos of food, travel, and décor—three of my favorite things.

· The art of telling a story with a beginning, middle, and end through your grid.

· How to effectively take a flat lay (and, uh, what a flat lay even is).

· Avoiding—and embracing!—dreaded Instagram clichés.

· How to turn Instagram into your own personal city guide.

Let's go—more picture taking awaits!

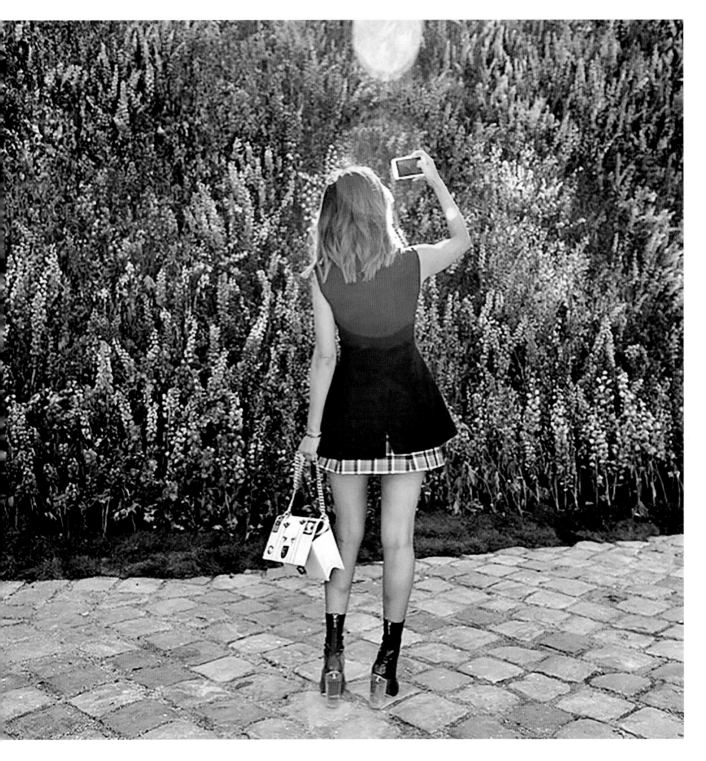

Apple vs. Arm Swag:
Choosing Your Subjects Wisely

There's a reason why so many millions of people are attached at the hip to Instagram: They're all visual creatures. Instagram is composed of individual images, but the photos you see are often much more than random moments. These photos can work together to help you tell dope stories about your holiday vacation, your brother's graduation weekend, or a Friday dinner with friends. And there's a way to do it right.

First things first: You need to choose a subject—no easy feat when your camera phone is always on you, just waiting to take a shot of every pretty flower, foamy latte, and quotable neon sign you might see any given day.

A good mandate when deciding what to post in a world full of opportunities is always to return to your mission statement. Does your photo make sense and align with your mission? If the answer is no, scrap it. If the answer is yes, you have one

more question to ask yourself: Is the photo something that your followers will love (or you love enough to share anyway)?

I've been on Instagram long enough to have established my voice. I include plenty of #OOTD inspiration, tacos and ricotta pancakes (my favorite foods, though pizza, ice cream, and In-N-Out burgers make regular appearances, too), epic sunsets by my house in L.A., and detail shots of shoes, shades, flowers, and the like. I try to fill my feed with everyday fun stuff, while posting categories I know my followers really like and respond to.

If you're new to Instagram, there is going to be trial, error, and experimentation to get this right (which was absolutely true for me, too). For example, I used to post a lot of pictures of my dog, Charcoal. Although he's the cutest dog in existence (obviously), I didn't want to overload my account with pictures of him. So I made him a separate account. (That's another tip: If you're planning an endless stream of Fido photography,

make an account just for your pet.) And because the people who follow Charcoal's account are way into pet pictures, Charcoal's snaps get the Insta love they deserve. Bottom line: Know your audience, choose your subjects wisely, and give them what they want.

Food, Travel & Décor: *Your Daily Diary*

While I think that mostly anything goes when it comes to the subjects of your images, there are definitely major "Dos" and some pretty big "Hell Nos" when it comes to the techniques needed to capture different themes.

FOOD

If you follow me on Instagram, you already know that I seriously love to eat. Tacos, avocado toast, ice cream—all of it (the working-out part isn't half the fun). So it's only fitting that food is one of my favorite things to photograph. But I don't do it because I genuinely think people care about what I'm eating; rather, I take food photos because meals are normally a highlight of my day, and they are often beautifully presented and thoughtfully prepared.

There are certain foods that trend on Instagram, as well. Desserts are always a popular choice (donuts, anyone?), as is anything brunch-related (especially that aforementioned avocado toast; extra points for a poached egg). Generally, you can make any food look good as long as it's appetizing-looking in the first place; you just have to train yourself to think like a food stylist. Easy as a piece of pretty, posted pie. Here's how it's done:

Timing. My friends know by now that I have to take my picture before they start to eat (or they'll be banished from future meals), so make sure you get what you're after before everyone digs in at your own table. (Sometimes an already grubbed-on meal makes a cool shot, too. More on that on page 126.)

Arrangement. Arrange the dishes on your table neatly and make sure everything looks clean (a dirty tablecloth and used napkins are so not appetizing).

Lighting. The right light is essential when it comes to food photos. Dark photos tend to be grainy—not ideal for dinnertime shots. At night, stay away from a restaurant's harsh overhead lamps and don't be afraid to ask your friends to turn on their phone flashlights to help light the way. During the day, natural lighting is always best, so try to snag a booth by a window whenever you can. But beware of putting your food right into a spotlight stream of sunshine, which can make your Sunday eggs look blown out.

Angle. A bird's-eye view from overhead or straight on are my favorite ways to shoot food. If you can't fit everything you want into the frame, never apologize for standing on your chair or booth—even if you're at a restaurant. (Just be sure to take off your shoes and wear clean socks. No matter how many potential customers your account reaches, no maître d' will forgive stiletto holes in their leather, and no fellow diners will forgo dirty looks if your little piggies are too close to their penne.)

Style the shot. With a good overhead shot, you can also capture surface detail like the wood grain of your table, a beautiful marble countertop, or whatever is surrounding your dish. And you can add props. Think sunglasses, a monogrammed wallet, or a newspaper or magazine. Even the interesting pattern of your plate or a linen napkin adds intrigue (as does a simple herb, a quick sprinkle of cheese, or a dollop of sour cream on top of an otherwise boring bowl of chili). Just don't add anything too distracting or busy that takes away from the real star of your shot—your edible subject. And because you'll want a frame that's full but not messy-looking, try to leave half an inch of space between each of your items.

Embrace imperfections. A gorgeous food shot doesn't need to be a perfectly plated dish. Grab a spoonful of your morning oatmeal with a pretty, fresh manicure and a cool ring, and all of a sudden your breakfast shot takes on a whole new dynamic. Holding a cone of half-melted gelato makes a standard dessert image come alive. An epic piece of birthday cake with runny frosting, crumbs, and a missing chunk is nothing short of a fiesta. These are the details that make your food moments real. Of course, if the "real" food looks unappetizing, skip it (no sloppy curry or Thanksgiving dinner plate with a mac and cheese/stuffing mash-up, please).

Distance. I don't think there is a standard distance you should hold your phone to snag the best food porn. But remember earlier in the book when we talked about cropping? Follow that

1 2

3

1 Taking a bird's-eye shot of my meal, standing directly above the table.

2 Voilà! Overhead perfection.

3 If you want to get the full meal into focus, taking the photo from an angle isn't as effective.

method for your food images. Ditch the zoom, hold your phone a minimum of ten inches away, and crop in during editing to get a clear close-up of your feast.

1 2 3
4 5 6

1 I composed my breakfast so it sat on the table at an interesting angle and showcased the micro-tiles.

2 Avocado toast with an egg looks delicious enough on its own, but a pretty plate never hurts.

3 Breakfast plates angled diagonally and slightly extending beyond the square—a way more interesting composition than perfectly framed and centered.

4 Acai bowls are my favorite (and so are those sandals and arm swag, so they made it in, too).

5 Poolside dining. Playing with four diagonals in this shot (count 'em).

6 Burger break with some outfit detail.

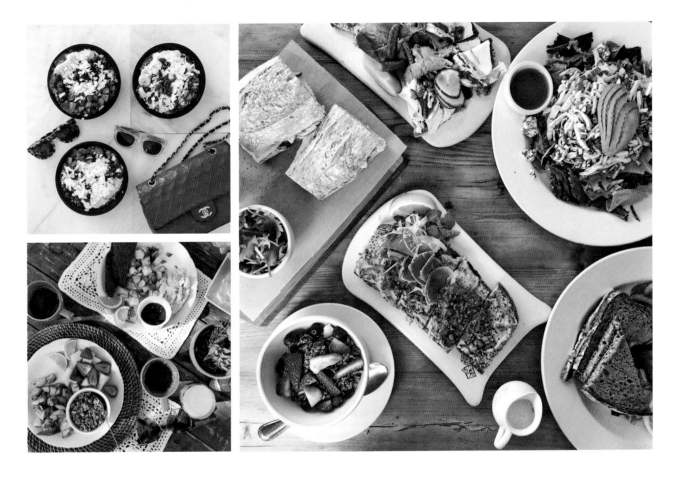

1 2
3

1 More acai bowls! Picking up the berry red in my Chanel purse.

2 The plates, bowls, and sandwich board were strategically placed and organized in a dynamic way to keep movement in the shot.

3 Alone, this breakfast would've been boring. But the different textures of the place mats, plates, and wood-grain table make the shot interesting.

Your Turn

Spending some time in your kitchen tonight or planning a fun dinner out with your girls? I want you to take your camera phone and practice taking a bird's-eye shot of food on a table.

- Cook or order something that actually makes you drool. You don't want to be Instagramming a picture of a half-frozen chicken potpie you have no desire to eat, do you? Hell no. Pick something delicious that gets your taste buds pumped.

- Before you or your squad starts going to town on the grub, decide what items should be styled for the frame (plate of food, pretty silverware, cappuccino cup) and what items should go (messy paper napkins, side dish of mystery sauce that may look murky to anyone not looking at it IRL). Then choose one or two extra accessories to introduce into the shot and give them context and personality—think sunglasses, your wallet, car keys, a friend's cool phone case, or anything else non—food related.

- Now arrange the shot, using the rule of thirds that we talked about at the beginning of chapter 2. Hold your phone ten inches above your food (stand up at the table or stand on a chair—with clean socks, as I mentioned), make sure your phone's grid feature is on, and place the star of the shot (the main food item you want to stand out most) in between a set of grid lines. Try to leave some negative space in your frame, too—as mentioned, at least half an inch between items is a good start-

ing place. Keep arranging and looking at your phone's screen until you settle on something that looks good. Remember, your items don't have to fit perfectly in the frame—you can crop to fit later, leaving certain things half in/half out if necessary.

· Clean up any and all plate splatters, dirty silverware, and anything else that makes the shot look unappetizing.

· Though your best option is utilizing natural light, turn off any harsh overhead lighting if you can. If that's not possible or you're at a restaurant, ask your dining companions to shine their phone flashlights onto your tablescape. Just don't use your flash!

· *Snap, snap, snap.*

· Have one you love? Great, now you're ready to postproduce the shot. Open up your Snapseed app and import your photo. Using your judgment (and your eyes—the postproduction process is very much a subjective matter of "this looks good" and "this looks bad"), brighten your photo, play with contrast, and, if needed, increase the saturation so that your food looks even more colorful. Repeat until you think the photo looks better than what you started with. (And

remember: You're simply enhancing the image, not completely transforming it into something unrecognizable. So use a light hand.) Save your photo to your phone.

· Open up your VSCO Cam app and add what I really hope you've now chosen as your signature filter. Save your image.

· Open your image in Instagram and crop in as needed. Congratulations. You just produced drool-worthy #foodporn. Bon appétit!

TRAVEL

I love to travel and honestly pinch myself every time I get to visit an exotic locale. But some of my favorite trip photos were taken the closest to home. A day trip to a neighboring town, a new hood you've been wanting to explore, and even a staycation are photo-worthy (the best kinds of trips are the ones you don't have to spend two weeks packing for anyway). As far as I'm concerned, you're technically traveling any time you leave the house. So learn to embrace all your adventures—no matter how big or small—and share them with your followers in a beautiful way.

When I take journeys far from home (always counting my lucky stars the whole time), I also use my trips as an opportunity to take both architectural and scenery shots that give my followers a true sense of the place. I visited Croatia for work last summer and made sure to take pictures of not only Dubrovnik's gorgeous, majestic rocks and beaches, but also the city's rustic stone streets, the interesting tile work at the house I stayed at, and—as you'd expect—the amazing pizza and seafood I ate. I took a ton of photos throughout the trip because I didn't want to forget a single second. And when it came time to gram, I tried to tell a complete story of the trek with a beginning (an airport shot with my luggage), many middles (the aforementioned beaches, buildings, and meals with some outfit posts and accessory details for good measure), and an end (a pretty water scene that I captioned with a simple "See you soon").

Again—I repeat—you do not need to go far to successfully tell a good travel story. I employ the same photography methods on work trips to Croatia as I do when I spend a day riding bikes on the beach twenty-five minutes from my house.

Regardless of where you are, you don't want your followers to feel like they're being forced to endure a boring vacation slideshow that never ends (and when you're sitting at your desk

one day, you'll want to look back at your feed with fond memories of your trip's favorite moments). So these are the things to do when taking travel shots:

Forgo the square. Yes, it's tempting to take all of your future Insta shots with your phone's built-in square crop. But when it comes to travel scenery, take a regular photo in order to get as much of the scene into the frame as you can; you can always crop later if you want to post in square form. (Though don't forget, you can now post vertical and horizontal images to Instagram. Hoorah! When you go to post your photo on Instagram, you'll just tap the two arrows in the bottom left corner of your photo and your picture will automatically size to its original orientation. So easy.)

Lose the zoom. Instead of using your phone's zoom to zero in on details, take the photo as close as you can get to your subject and crop later so you don't lose quality and get stuck with grain.

Follow the light. Back in chapter 2, I told you that the golden hour—the time just after sunrise and just before sunset—is my favorite time of day to take selfies. The same goes for gorgeous landscapes and scenery (I dread waking up for sunrise hikes, but thankfully the golden L.A. cityscapes they yield make the pain worth it). Planning your sunrises and sunsets can be vital, so google the exact time and get yourself to a place with a view. If you *really* want to get technical in your planning, there's an app called Sun Seeker that tells you the sun's exact position in the sky at various times of the day.

Play with perspective. A beach, waterfall, or adorable side street can look good alone. But to capture the scale of the place you're shooting, add yourself (or a travel buddy) to the shot. A relatively small person next to a big national monument or even bigger part of the landscape can be majestic. Also, remember to look up. Trees, buildings, and mountains have a much different point of view from the ground up.

Don't forget to look down. Taking pictures from high places is incredibly helpful when it

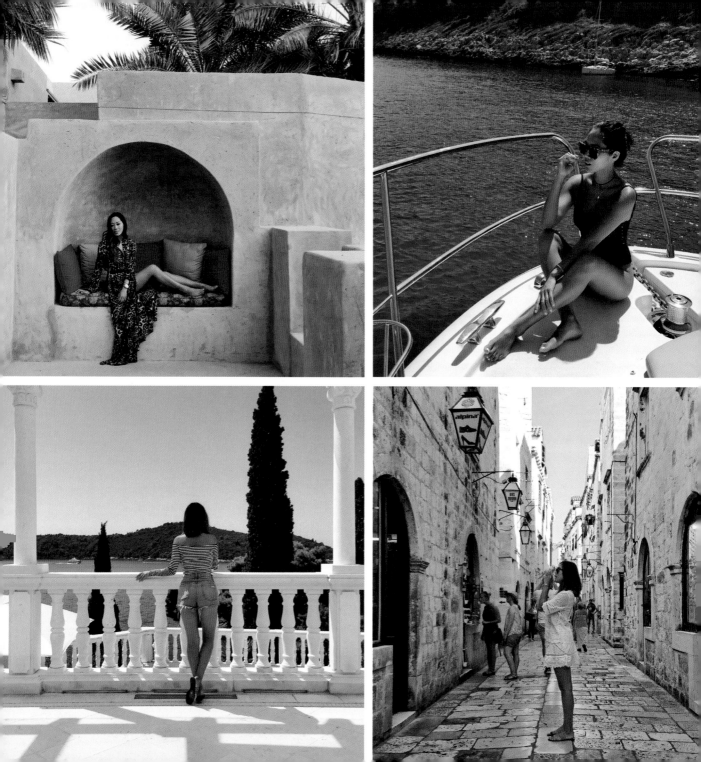

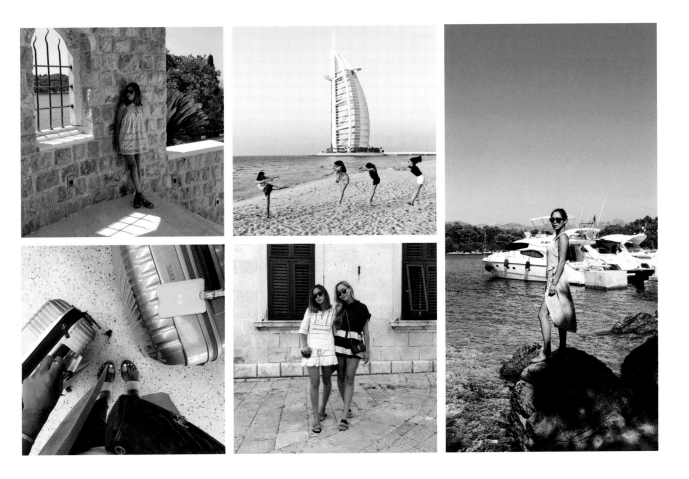

1 2 3
4 5

1 A stone wall in Croatia was the ideal complement to my lace dress.

2 The Burj Al Arab hotel in Dubai with a kick. My friends jumped at the same time so it looked like I blew them away.

3 In front of a yacht in Croatia. Now is a good time to say #blessed.

4 A beginning shot for a travel story.

5 An outfit photo with my sister, in old city Dubrovnik.

comes to travel shots. Think hiking trails, cable-car rides, observation decks of buildings, and balconies. You can even take a picture through a window. Just make sure it's clean (duh), and press your phone up to the glass to minimize glare.

Make it original. Certain places have that special je ne sais quoi that is the stuff of Instagram legend (restaurants with pretty twinkle lights, this means you). Even when I visit popular places and attractions, I always try to be as original in my shot as possible. So if you find yourself at, say, the Eiffel Tower, think about how you can shoot it in a creative way that hasn't already been done to death. Take a picture from underneath. Find some charming flowers to focus on and shoot the tower through them. Also, whenever I know I'm somewhere that could be considered an Insta cliché (more on that later), I tap the location's geotag, pay attention to the top photos taken there, and avoid anything similar.

Don't forget the details. While epic landscapes make beautiful travel shots, smaller moments that capture a sense of culture are equally important for bringing a locale to life. I have an obsession with intricate tiles (hence my use of the hashtag #IHaveThisThingWithFloors). So Italy, with its gorgeous tile work, is a particularly good place to capture a detailed travel moment. Same goes for the epic double doors of Paris and the green-tea lattes in Seoul.

Keep things straight. By now you know my pet peeve of crooked pictures. Use your camera's grid feature and also post-shot editing tools so that your horizon line is as straight as an arrow.

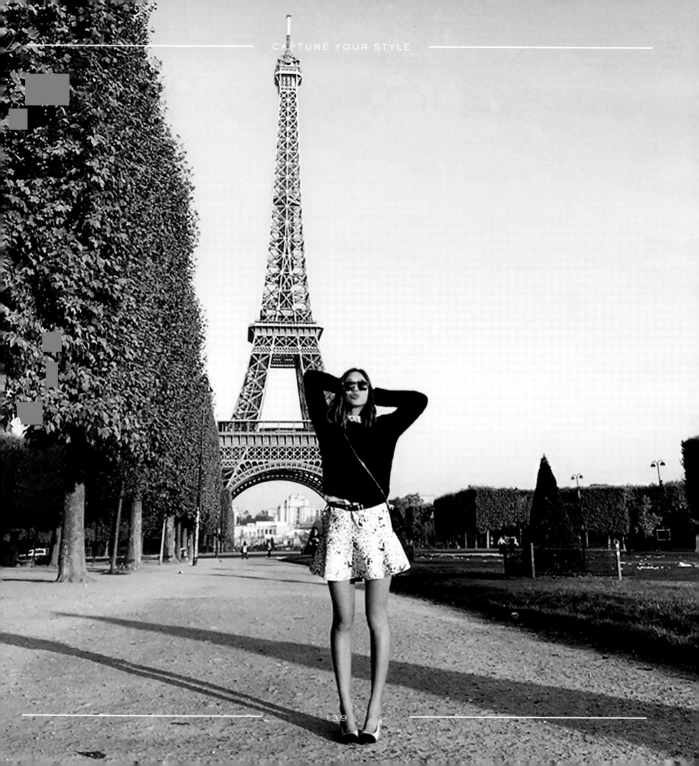

DÉCOR

Interior design is my passion and first love. At the beginning of this book, I mentioned that I had fully planned on being an interior architect and described the crazy journey that ultimately led me to my blog, my Instagram account, my clothing line, this book, and all of the unreal opportunities that came my way because I moved to San Francisco to study interiors.

Though *Song of Style* began as an interior design blog and quickly morphed into fashion, I'm still obsessed with décor and find inspiration in spaces wherever I go. I always notice lighting fixtures, tile work, and color schemes and find myself snapping eye-catching vignettes inside the restaurants and boutiques I visit. Interior design inspiration is everywhere (I've taken pictures of delightful furniture and flower pairings at my local nail salon), and posting photos of pretty décor is a good way to share your taste as well as inspire creativity among your followers.

You have endless options when shooting interiors and décor. Do you want to capture an entire room or curate your nightstand to showcase a few of your most treasured possessions? I say do both!

Here's the procedure:

Use natural light. Shoot during the day with the blinds and drapes open—but when the light is evenly diffused throughout the room, rather than harshly streaming directly into the space like a tractor beam. A narrow stream of really bright sun actually makes it harder to get a properly lit shot. Turn off any artificial lights. And, if possible, wait for some overcast vibes. Clouds act as a natural light diffuser and imbue softness to your lighting scheme.

Clean up. Remember in chapter 2 how we discussed selfies and the potential home hazards (aka dirt and disorganization) that could be lurking in a mirror shot? Well, your cleanliness is even more important when your space is the

star of the show. Get rid of any unintended clutter (paper piles, mail stacks, laundry in need of a fold, exposed cords, and other casualties of living that we all have but that can be kept away from the Instagram community).

Look for symmetry. Sure, you can seek out symmetrical themes in your subject (e.g., bookshelves flanking both sides of a sofa; two of the same comfy, colorful pillows on a bed). But the real key here is symmetry in space. If you're shooting said pillows on the bed, make sure you leave an equal amount of space open on either side. Same goes for that sofa and the bookcases. Symmetrical images are pleasing to the eye (and interior designers often create epic spaces with this principle in mind), so get in on it.

Shoot from the corner. No one puts baby in the corner. Except when taking interior shots. Tuck yourself into every junction in the room and see which angle makes for the best shot.

Slay the vignette. Here's some Interior Design 101: A vignette is a small grouping of objects that come together in a portrait to tell a story. So think about a vase of flowers, an alluring lamp, and a vintage, framed photo of your grandmother on the nightstand next to your bed. That's a vignette. Or a group of art and design books on top of a coffee table with Diptyque's yummiest candle sitting nearby. That, too, is a vignette. When curated in your own space, these small groups of like-minded objects say a lot about your taste. They're readily found outside your home, too, at boutiques, cafés, apothecaries, salons, and other decorated spaces.

LEFT The Kenzo showroom in Paris. To capture this beautiful staircase properly, I made sure the vertical and horizontal lines were perfectly aligned.

RIGHT The lobby of a hotel in Beverly Hills. The chandelier makes the eye travel up from the horizontal salon wall.

1 2 3
4 5 6

1 Had to capture the art and iron chandelier (elements of a room I always try to shoot).

2 I took this at one of my favorite L.A. nail salons, Enamel Diction, at night, so it wasn't originally the brightest. I lightened the image in Instagram.

3 Flowers and heels always make great interior props.

4 To capture the beautiful architecture of this hotel in Todos Santos, Mexico, I stood at an angle and kept those vertical lines aligned as straight as possible.

5 To get a perfect vignette by my bed, I stood eye-level with the side table and products instead of capturing from above or below.

6 At my favorite L.A. spa, The Now. I wanted to capture its Tulum-inspired decor.

ABOVE To capture the symmetry of this West Hollywood room, I stood on a staircase directly opposite of the mirrors and aligned them with the grid tool on my phone's camera.

OPPOSITE Gorgeous, dramatic light in my bedroom

Your Turn

Ready to take an interior shot befitting Kelly Wearstler's biggest client? Your homework here is to take an architecturally driven photo of an interior space—either in your home or in a restaurant, boutique, or other wow-inducing establishment where you glean major design inspiration.

- Choose a space that is filled with natural light, and shoot during the day. Heavy artificial lights will ruin the shot. If you're not in public, turn off all the lights and open all the shades. Flash is a major no-no here, too.

- Again, if you're not in public, remove all cords, remotes, and household crap from the shot. If you're at a restaurant or boutique, try to capture an angle of the space that has the least amount of said crap.

- Turn on your phone's grid feature and use the space's architectural lines as your guide, pointing your camera straight on at one of the space's walls. Make sure the space's horizontal and vertical lines seamlessly line up within your phone's grid.

- *Snap, snap, snap.*

- Open your Snapseed app and import your photo. Lighten/darken, play with saturation and contrast, and sharpen as needed. Crisp, bright photos are an absolute must here, so experiment with

Snapseed's tools until you have a photo that you think resembles something out of an interior design book (sharp, bright, full of deep and vibrant colors, straight). When you're ready, save your photo.

· Did a random electrical cord sneak into the shot? Maybe there are some dirty napkins and cups at the coffee shop that is otherwise completely gorgeous? Open your Facetune app and import your image. Here's where the app's Patch tool comes in handy. To remove unwanted items from the shot, zoom in super close on the section in question, tap the patch icon, and then tap on a part of your image that you'd like to use to cover up the part you're trying to remove (for example, a green wall behind the table trash you don't want). You'll see two circles appear; one circle will copy whatever happens to be underneath it in the shot, while the second circle acts as your paintbrush, laying down whatever the first circle copies. Get it? Good. Now, pinch inside either circle to either shrink or enlarge it based on how precise you need your cloning to be. You can also tap inside either circle and move it around to create more or less distance. Play with this feature until you feel comfort-

able with it (trust me, it takes time to master it, so don't be afraid to import all kinds of images and practice patching). When you feel ready to save, go forth.

· Open VSCO Cam and lather, rinse, repeat until you have your signature filter firmly in place.

· When you're ready to upload your shot to Instagram, crop as needed. And *fin*— you're a modern-day Dorothy Draper.

Storytelling Through the Grid

When I first started my Instagram account, my storytelling sucked. I posted random photos too sparingly—it just wasn't interesting to follow. These days, my storytelling skills are getting better because I think about my grid in terms of three, six, and nine—numbers you should always remember when playing the Instagame.

You're already thinking in twelves to make sure your overall grid is cohesive and aesthetically similar, so when you want to weave a tale with multiple photos—for our current purposes that's a visual tale with a beginning, middle, and end—make sure the first three, six, or nine of your grid squares flow and complement one another.

Also, keep in mind that the first three, six, nine, and twelve images of your grid are the world's first impression of your feed. If you happen to have a blog, e-commerce site, or boutique, consider those pieces of your business your house.

Instagram is your front lawn. You want your lawn to be clean and appealing to the eye, an invitation to knock on your door, step inside, and look around. The story line you set up through your first few photos on the grid has to be on point.

Whenever I travel or am planning a few days of something out of the ordinary—say, throwing a Fourth of July weekend for my friends or going to a car show up the California coast—I think about how my journey can tell a proper story (complete with beginning, middle, and end) so that my followers know what to expect. Posting transitions are important, and when I'm about to go away, I like to post a photo of my luggage or what I'm packing, which lets my followers know I'm headed on an adventure (this also helps me get very excited for what's to come).

You don't have to be doing anything exotic to tell a compelling tale. Let's say you happen to be

at a really picturesque restaurant (twinkly lights, anyone?) and eat a tasty meal. You could post an #OOTD shot before you head out, an interior shot to show off the restaurant's cool décor, and then a food photo of what you're about to eat. As long as your story has a beginning, middle, and end, you can turn everyday situations into fully Instagrammable moments.

Last Fourth of July, I threw a fun, low-key party for my friends in L.A. and invited my girls to come eat, swim, and watch fireworks by the beach. It was totally chill and intimate, an absolutely perfect occasion for putting my storytelling chops to good use.

Beginning. I set up the weekend with a flat-lay shot of the denim cutoffs, sunnies, and my own Two Songs sweatshirt I planned on living in all weekend.

Middle. As the weekend went on, I grammed shots of the fun things my friends and I were doing.

1 2 4
3

1 Flat-lay shot of my weekend outfit, artfully arranged poolside.

2 Calm before the storm: the serene patio at the Calamigos Ranch in Malibu before some major Fourth of July festivities began.

3 The flamingo was hungry, too.

4 The aftermath—ditched the flamingo and ended the weekend on the swan with my dog, Charcoal.

Evening swims, well-styled patriotic food, and brunch shots (and a couple of In-N-Out snaps for added Americana), as well as some less-than-graceful moments for humor (I completely ate it while floating on a giant inflatable bird in the pool—not my finest moment). The important thing here was to capture the weekend's most memorable aspects while also giving my followers a true sense of place, allowing them to feel like they were part of the festivities (and hopefully to get inspired for their own July Fourth extravaganzas).

End. After a long weekend in the sun, I was pretty spent. So my final post from my July Fourth weekend was me on a swan float with my dog and a simple caption: "Chillin'."

Not every gram is going to fit into a larger story scheme. When that's the case, you should still be thinking in three, six, and nine and making sure each photo looks good with the previous one—if not in subject matter, then in aesthetic and color family.

Let's get back to VSCO Cam, the postproduction app I mentioned in the last chapter. It has a built-in grid feature so that you can actually do a "dress rehearsal" before you post anything live on Instagram. I always post to my VSCO grid before anything hits my feed. If a photo looks weird next to the previous image or messes up the general flow of my grid, I scrap it, test another photo, and only post when I feel like the grid looks on point.

Everyone is a storyteller, and everyone has a different story to tell. My friend Zach has a travel company called @passionpassport (his own feed is @zachspassport), and he tells amazing visual stories about the connections we make when we travel. My friend Cubby (@cubbygraham) works for Charity: Water and takes really beautiful pictures of his friends and tells their stories in the captions. There is no right or wrong way to craft a narrative as long as you're being authentic, and if your grid looks good, your message will come across much more effectively.

Flat Lays and Product Shots:
The Good, Bad, and Ugly

You've for sure seen a flat-lay shot while doing your usual morning Insta-procrastination scroll. For those unfamiliar, a flat lay is a bird's-eye photo of a grouping of strategically arranged items that typically share a color scheme or theme, and they are frequently posted by retailers to show off new arrivals or what they have in-store.

When done right, a flat lay is a visually dynamic photo type that looks like it popped out of a catalog (and can help entice your following to go buy said pretty products, if that's part of your mission statement). When done wrong, the flat lay just looks like crap. The purpose of a flat lay isn't all about bragging about what you have, but more of a way to showcase the pieces you love in a neat way.

Similar to the non-blurry, bright, non-zoomed-in way we discussed taking food photos, the goal of a flat lay is to show off a group of curated items—clothing, accessories, jewelry, even electronics—in a pleasing, innovative presentation. To do that you have to think like you're Net-A-Porter's star product stylist, arranging items in a way that looks good but also creates a covetable environment.

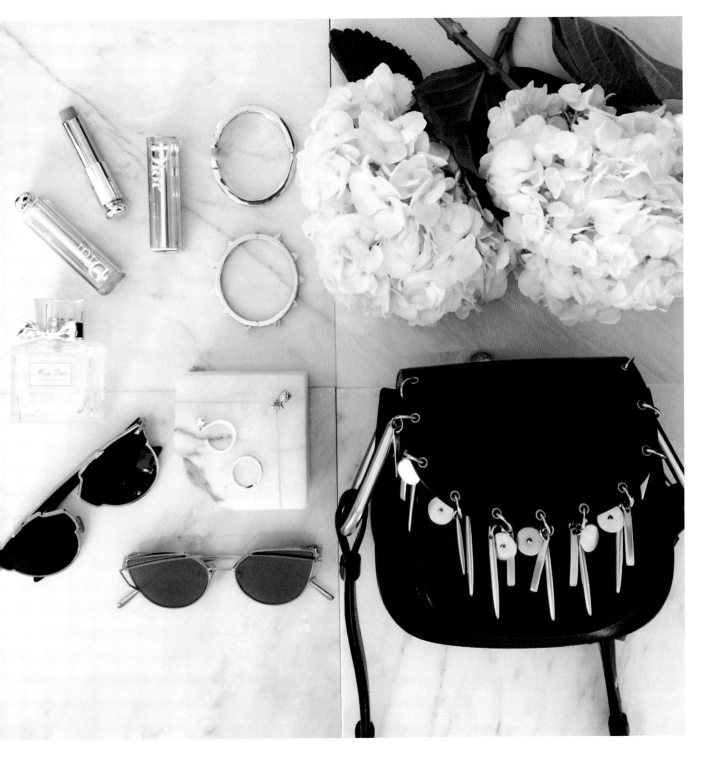

1 2
3 4

1 Beauty products make for good flat lays. I wanted to share my favorite lipsticks with my followers, so I aligned them with their caps off to show the different shades.

2 The contents of my Celine bag happened to have gold accents— Dior sunnies, a Larsson Jennings watch, and bracelets.

3 Outfit preview—white motif.

4 Outfit preview number two— all black.

Before you can start gathering your items and posting a shot that gets the double taps flowing, decide what kind of flat lay you're going to do and why. Here are a few of my personal favorites:

01 **The Beauty Breakdown.** Eva Chen (@evachen212), Instagram's head of fashion partnerships, does a monthly flat-lay roundup of beauty products she digs, and I, too, post photos of the lotions and potions that make up my morning routine. This is especially pretty when your skin-care bottles are, too.

02 **What's in My Bag.** This one shows off—you guessed it—what's inside your purse, clutch, backpack, or the like, along with the bag itself. These can be themed by different occasions for an extra twist (New Year's Eve or Back to School editions, for example).

03 **What's in My Luggage.** Just like "What's in My Bag," only this one showcases the goods you're packing for an out-of-town adventure. (This is a great one to do if you're setting up the beginning of a travel story, as we discussed earlier in the chapter).

04 **#OOTD.** Who says your outfit of the day has to be *on* you? You can totally arrange the pieces you're about to put on in a pretty square and post away.

05 **The Product Flat Lay.** Did you just get a new pair of heels that you're dying to show off? Or what about the latest Dior shades you've been saving up for and finally pulled the trigger on? Sometimes I like to create a flat lay around a specific piece, using similar tones for a cohesive (yet slightly OCD) look.

These are just a few suggestions, but you get the idea. As long as your products go together in some way—as I said, either in color (all black everything) or theme (five cool things you got for your birthday this year; July Fourth party gear)—your flat lay will be on its way.

Now comes the fun part: gathering your goods. When building a flat lay, pick out an

anchor piece that holds all the images together. If you're doing a "What's in My Bag," the anchor is likely going to be your handbag itself. Unless you happen to be lucky enough to own the latest Rimowa hardcase, the anchor of a "What's in My Luggage" shot might be a really cool crocheted dress you plan to wear on the trip. It's imperative you think about having a "star" of the shot, because you're going to build harmony and balance around that one piece. Then you'll want to grab a few like-minded items to sprinkle into the frame (here's where your curatorial and editrix skills come in). Ask yourself if the items make sense in a larger, overall lifestyle scheme of things (a pair of flip-flops probably wouldn't go with a bejeweled evening clutch for a #WhatsInMyBag, but the lip balm I love, the cute patterned travel umbrella I carry, and my really cool iPhone case, on the other hand, would).

There is no right or wrong number of items to include in a flat lay; the more important thing here is harmony and balance within the photo. You don't want it to look too cramped, like every item is competing for screen time. But you also don't want your shot to feel like an empty box with way too much white space. The products should look clean and uniform, with equal space in between each item—no matter what size or shape they are.

You'll have to play with the products and find what types of arrangement are most pleasing to the eye by trial and error. And you definitely don't have to keep all of your products facing in one direction—get creative and tilt your products so that they aren't super straight, unless super straight is what you're going for.

My flat-lay checklist, which should be memorized stat, appears on the following page.

FLAT-LAY CHECKLIST

01 **Start with the square.** This is one type of shot where everything needs to fit into a square, so take the photo using your phone's square mode.

02 **Background is key.** Keep your background simple, but have fun with it. A white marble countertop or simple white bedsheet are two of my favorites. No marble to speak of? Buy a roll of marble-printed paper at the craft store and fake it. Brown butcher paper works, too. Just make sure that you shoot on a background that contrasts with your items. If you're shooting brown sunglasses and a brown clutch, they'll get lost against your brown hardwood floor.

03 **Use natural light.** Just like with the décor shots we talked about earlier in the chapter, you never want to use artificial light for a flat lay—unless you want glare. Try to shoot in a room that's sunlit, without direct light hitting your items.

04 **Balance and harmony are good.** As I said above, make sure your products are grouped together so that the shot looks balanced. You don't want too much white space in between items or on the top, bottom, and sides of the group, but you do want enough so that your square doesn't look messy and cramped. There's no exact science to this, so you'll have to play with your products until you feel like the picture doesn't suck.

05 **Shoot from above.** This shot only works from a bird's-eye view, and you have to hold your phone perfectly—and I mean perfectly—straight, with no angle whatsoever, or you'll get weird distortion. Stand on a chair or stool, hold your phone high enough to get all of your intended items into the frame, and go to town.

Avoiding Insta Clichés

You've likely seen the following while scrolling through your feed:

· Workout selfies
· Legs in front of a beach or pool
· Sunday-brunch spread
· An airplane wing
· Foamy-latte art
· The air jump
· A MacBook in bed

These, my friends, are Instagram clichés. And they exist for a reason: legs look sexy in front of a beach or pool, latte foam looks cool, and brunch is delicious. We're all guilty of posting at least one of these (or in my case, uh, most of them). But I don't actually think clichés need to be avoided entirely. You should know my philosophy by now; if it's something that evokes a feeling or memory of happiness, it deserves to be photographed. While even the most grammed subjects are fair game, that doesn't mean you have to photograph it the same way as everyone else.

As I mentioned earlier in the chapter, when it comes to taking pictures of frequently posted restaurants, tourist attractions, alleys, museums, hotels, and other locales that often populate my feed, I play a game to see how differently I can capture that place—especially because I constantly find myself at locations and events that are packed with fellow bloggers who are also gramming away. Using Instagram's Search and Explore feature, type in the place you're getting ready to shoot, and you'll see both the "Top Posts" and the "Most Recent" posts that were shot there. Notice what the top posts look like. Then get creative and take your shot in a completely different way.

Think about how you can improve upon what's already been posted. This isn't about competing with the Instagram community, but,

rather, trying to challenge yourself through your photographs. This method pushes your creative boundaries and brings out your true shutterbug.

Here are a few other ways to deal with shooting a popular, clichéd place:

Put someone in the shot. Sure, you can take the same photo of the Brooklyn Bridge as the millions of other people who've posted it before you. But putting yourself or someone you love in the shot automatically makes it a photo that's truly unique to you.

Put *something* in the shot. Flying solo and not having a good enough hair day for a selfie? Grab an ice cream cone, a pair of shades, a cute, quotable greeting card, or any other prop you have handy, and shoot your item in front of what might be considered a clichéd background. Despite the photo still being technically clichéd, the addition of you or an item that is meaningful to that particular moment automatically makes the shot distinctive.

Put the caption to work. Captions go a long way. And if you know you're taking a super-clichéd photo (air jump in front of the *Tour Eiffel*, perhaps?), don't be afraid to infuse some self-deprecation and wit into your post. I've literally captioned clichéd images with one word: "Cliché." As long as you can laugh at yourself, your followers will, too.

When it comes to Insta clichés, location won't always be the thing that's overdone. Sometimes a cliché will find you in the moment instead—the "passport before takeoff" photo, for example. The key here—as with any clichéd shot—is to make it your own. When I travel for work and want to set up my trip with a passport picture (you've seen these in your feed for sure), I'll shoot it in its patterned python case, which automatically differentiates it from someone else's passport photo. The same goes for the "legs in front of a pool" shot. Maybe you have a new toe ring or a cool pedicure color. For whatever clichéd shot you might take, always make the details unique to you, and then the photo is no longer just a cliché—it's yours.

1 2 3
 4 5

1 The Eiffel Tower attracts tons of tourists, so I woke up early one morning in Paris to ensure a shot without any photo-bombers in the background.

2 The laptop photo can be a cliché, but arranging breakfast in bed, along with an image of *Song of Style*, makes it meta.

3 While away in Paris, I was training for the L.A. marathon and decided to take the scenic route along the Seine.

4 I framed this photo and showed my friend exactly how I wanted it taken (by now, you know I like things to be straight). I had him take a burst of photos as I ran by LACMA's *Urban Light*.

5 The shoe selfie done right.

#InstaGuide: *Using Instagram to Explore Cities and Discover Great Food*

My favorite thing about Instagram is its global community. At the time of writing this book, there are 400 million users sharing their photos. It's literally its own search engine. And that means there are millions upon millions of hashtagged places the world over and, within them, countless geotagged restaurants, bars, festivals, and the like, each just waiting to be discovered and shared with users across the globe. It's no secret that I love to travel, and when I'm visiting a new place, I no longer use a web search as my first means of planning an itinerary and researching spots to hang. Now I go straight to Instagram to search geotags, hashtags, and interesting locales and I build my trip from there. I even use Instagram to meet new friends in places I've never been (I can now say I have peeps in Chicago, Dubai, and Iceland, be-cause I sent direct messages to fellow grammers who had fascinating feeds).

Of course, you don't have to globe-trot to use the platform's amazing Explore features (I've found so many yummy tacos, exciting art exhibits, and vintage-clothing sales mere minutes from my house in L.A. by going down the geotag/hashtag rabbit hole). Instagram isn't just a place to post photos—it's a platform to discover dope places and events you might otherwise miss, no matter where you are.

This is how I do it:

Start with a hashtag. Heading to Dallas for a work trip? Spending the weekend at home in San Diego and looking for something fun to do? Using Instagram's Search feature, tap Tags and enter the name of the place you're curious about. You

can get super specific and search by neighborhood (the #LosFeliz section of Los Angeles, for example), somewhat general (#Chicago), or super broad (#Iceland—which is what I searched when I visited there for the first time last summer). Searching this way will show you the top and most recent relevant posts, along with related searches that you can try, too.

Fall down the vortex. Here's the fun part: Your search will yield thousands of results, and it's your job to tap on photos that look interesting. When you find a picture you like, tap on the username of whoever took it and pay attention to the other recent photos in their feed. If they seem like someone who has the same interests as you, the other spots they've grammed in the area you're searching might also suit your fancy (I look for people who post fashion, travel, and food pictures, which lets me know we likely have similar tastes). When I see a restaurant, brunch spot, landmark, or boutique that looks interesting, I'll tap on that place's geotag (or search for its name in the Places field) and do a bit more investigative research. If it looks like a pretty spot that seems to have good food and atmosphere, I make a note to visit there.

Do your homework. For an added layer of detective work, consult Yelp for the details of the Insta-favored spots you found (hours, best menu pick, best time to go, etc.). That way, there are no surprises when you get there.

Here's where Google comes in. Once you've spent time exploring, go back to Google and search for the top Instagrammers in the particular city you're curious about. You'll find a ton of lists and roundups of top Instagrammers on all kinds of reputable sites such as the *Huffington Post*, *Who What Wear*, *BuzzFeed*, *Refinery29*, and *Condé Nast Traveler*.

Insta search, part two. Once you're armed with this new info, go back to Instagram's Search function, tap People, and start seeing where these notables play in the city you're hitting up. When I

was in Chicago in 2014, I discovered two of the city's top grammers on the web—@swopes and @ pauloctavious—and immediately direct-messaged them both, saying that I was in town for a couple days and would love some recommendations (remember, I'll seriously talk to anyone). Both of the grammers responded, and they each graciously took me to some of their favorite Chi city spots (Lou Malnati's for deep dish, anyone?). Obviously, not everyone likes to talk to strangers as much as I do (and, like with anything on the Internet, you should use your best judgment and always be cautious), but know that top grammers are an amazing source of information—whether you meet them in person or not.

Check their followers. Once you find solid grammers, see who they're following. Chances are, they're checking out the feeds of other cool, local souls as well—people who can lead you to your next epic travel adventure or become a lifelong friend.

Instagram also has its handy Search and Explore feature, and within it a Trending Places roundup. This shows off the top posts from music festivals, concerts, and any fashion weeks and sporting events all over the world, in real time. Though you may not be planning a trip to any of the trending places anytime soon, checking out places that interest you and falling down the vortex is good trip-itinerary inspiration for when and if you decide to pull the travel trigger.

The above applies if you're looking to discover amazing food, too—which is always a top priority for me. Instagram has an amazing community of food-obsessed grammers who work as chefs or food bloggers or are just cool, regular people who love to eat. Food photography has taken on a life of its own, so it makes sense that hordes of both amateurs and professionals have taken to the platform with their taste buds and cameras in tow.

When I want to discover good food wherever I am, I follow the same protocol as I do when I'm building my general itinerary. Only, I start with a

web search of "top food Instagrammers," followed by the name of the city I'm visiting. Then I fall down Insta's black hole and tap around until I find meals that look particularly drool-worthy. Yelp is a must for double-checking that an intended eatery isn't just a place where I can get a cool shot in front of some romantic twinkly lights.

To get you started, here are some of my favorite food accounts to follow that do a great job of showcasing interesting restaurants all over the world (and make me drool every time I look at their feeds):

@infatuation

@bonnietsang

@tastingtable

@foodzmything

@weekendbreakfast

@lindseyeatsla

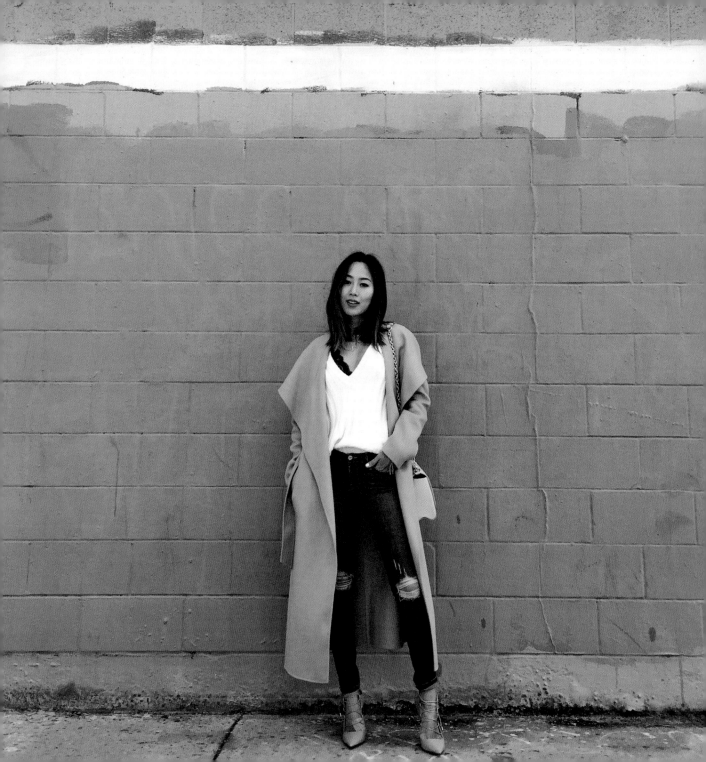

4

FIND &
GROW YOUR
AUDIENCE

Now that you're down with the dynamics of taking a perfectly beautiful, double tap–inducing Insta shot, let's get real. It didn't actually happen unless it's on Instagram. It's time to get you some followers (unless your feed is private) so you can start sharing amazing moments in your life.

My Instagram following has happened organically. I've never paid for followers, but instead stay true to my mission statement of inspiring people through stirring imagery that captures my life. While content is king and good shots are ultimately what's going to get you noticed, there are definitely tools and strategic tricks to use that will have your follower count creeping upward on a consistent basis. And remember: It's not all about growing numbers; it's about engagement, as well. It means nothing if you have millions of followers, yet only a hundred people are liking your images and aren't as engaged.

In this chapter, we'll work on the following:

- Hashtagging versus geotagging (and when to use them).

- How to tag, mention, and give social shout-outs like a boss.

- Starting and joining conversations the right way (without being a total creep).

- Why timing is everything when it comes to growing—and not pissing off—your followers.

Ready to grow that audience? Onward!

Hashtag vs. Geotag
and What It All Means

Though we've discussed hashtags throughout the book, here's a quick refresher: Instagram has become its own search engine, and a hashtag is a discoverable piece of text that allows you to see other images on Instagram that are also hashtagged with the same text. Anytime you put the # symbol in front of a word or phrase without spaces, it automatically becomes a discoverable hashtag that the community at large can tap on in order to see a waterfall of other photos that have been hashtagged with the same thing. Plainly put: It's one of the best ways for people to find your photos. Got it? Good.

There are two types of hashtags: ones used at events and ones that get more specific to your photo. So, for example, if you're hosting a red-carpet-awards-show viewing party at home, you might use #Oscars2016 so that your photo gets included in the general deluge of the day's content. But you could also create a hashtag that is reserved just for you and your guests (#AimeeDoesOscars) and makes it easier for your friends and followers to see photos from your party.

You've probably noticed specific hashtags used for various personal events (#ZachTurns30, for someone's birthday party; #AliGettingHitched, for a friend's bachelorette weekend) and for major marketing initiatives such as film premieres and fashion launches and huge events like #Coachella. These hashtags are effective because, when used en masse, they make your photo easily discoverable. This, in turn, gets more eyeballs on your work and gives you the greatest possibility

of being found by users who double tap your pics and follow your feed (which they obviously will, because you've been paying attention to this book).

Whenever you're at a concert, event, conference, or anywhere else large groups of people are congregating (church and high-holiday services excepted), make sure you look at marketing materials, the invitation, or the event website to see if they have an official hashtag. Then you can brand all or a select few of your photos from said event to make it easier for peeps to find you and get in on the conversation—in other words, like, comment on, and share your post.

Again, it's best practice to use this method when you're somewhere with a bunch of other people hashtagging the same thing. And if you're the one throwing the birthday party or the bridal shower, make sure you come up with a custom hashtag for your guests to use so that all of their followers can feel like they're in on the soiree.

Hashtags that are more specific to a particular image, on the other hand, are a different ball game. You've totally seen it (and might even be guilty of doing it): twenty different hashtags in the caption of a post. #Birthday #Cupcakes #Love #Balloons #Party #Flowers #Friends #Gifts #Happy #OMG #Stop #EnoughAlready #TOOMANYHASHTAGS. #UNFOLLOW.

Over-hashtagging is one of the most annoying things you can do on Instagram (other than posting way too much or uploading five selfies in a row—you know who you are). Not only is this irritating to your followers; it's actually not an effective way to grow your following.

But Aimee, you're probably thinking. *My mom and her friends do this all the time!*

Exactly.

Hashtags should be used sparingly and strategically if you want them to help grow your following.

HASHTAG COMMANDMENTS

01 **Use five hashtags, max.** Capeesh?

02 **Hashtag brands, not items.** Wearing a white shirt? Instead of using #whiteshirt, hashtag the designer. That way, fellow fans of the label will find you, and you're more likely to win their hearts.

03 **Don't use crazy-popular hashtags.** A quick Instagram search for #OneDirection yields more than fifty million results. Yes, fifty with six zeros. But if you scroll down the results list in that same search, you see that #onedirectioners has a mere thirty-eight thousand hashtagged photos, while #onedirectionobsession has twenty-five thousand. Sweet, you have options. Go with a lesser-used hashtag so that your photo doesn't get lost in the shuffle. This goes for popular words and phrases, too. #Love has an astounding 757 million search results (the number of One Direction fans who wanted to hashtag their photo but forgot). So get creative and skirt the line between completely popular and under the radar so that you have the best chance of rising to the top of searches.

04 **Keep your captions clean.** Again, a caption that's cluttered with a ton of hashtags is the best way to alienate your followers and get eye rolls for days. One or two in your caption is fine, and add the rest to a comment. (Ahem: Five is your max for the caption and the comments *combined*.)

Now that your hashtag game is #onpoint, let's talk about how to geotag your photos—yet another effective way for getting eyes on your beautiful photography.

A geotag is a discoverable tag that adds a geographical location to your post, allowing fellow grammers to find you based on where you've been. You've likely recognized a geotag on Instagram as the little place-name that lives just underneath someone's username when they post a photo. Instagram posts don't automatically have one—you have to add it manually. But once you do—in similar fashion to a hashtag—you can tap the geotag and see other photos that were geotagged to that place, too. Geotags, like hashtags, make your photos more discoverable.

When you're about to post a photo, you'll see "Add Location" on your Instagram screen. Tap inside the field and you'll get a list of suggested locations of where the great minds at Insta think you took the shot. Sometimes these will be spot-on; other times, not so much—in which case, you can type in wherever you were (or create a new location if wherever you were IRL is so cool and underground that it doesn't yet exist in the social media world). *Et voilà!* Now anyone who happens upon the geotag of the place where you took your shot—either by searching for it or by discovering it on someone else's feed—has a good chance of seeing your picture, too.

You can geotag as broadly or specifically as you want, using entire countries, cities, counties, bars, restaurants, boutiques, parks—the options are endless. One place you should never, ever geotag? Your house or any other private place that you don't want made public. You wouldn't put your home address—or your boyfriend's or mom's, either—on your Instagram profile for the world to see, would you? Geotagging is pretty much the same thing, so be smart about it.

You should also be mindful of geotagging your hotels, Airbnbs, and friends' houses when you're on a trip. I love to geotag the hotels I stay in when I travel, but I only do it after checkout.

Tagging and Mentions:
Your Social Shout-outs

Another way to help your photos get discovered by the Instagram community is through tags and "@ mentions." What are these magical things, you ask? Allow me to explain.

A tag is when you add someone else's user handle to your photo. They get notified that they've been tagged, and they then see your photo. Since Instagram is, at its core, a social network, tagging is the heartbeat of the platform: It allows you to essentially give a "shout-out" to someone on your feed, and your followers can then tap on this grammer's username and explore their grid.

You can tag friends and family who appear in your photos, pets if they have their own account, the handle of a store or restaurant you're patronizing—or anyone or anything else you're in the mood to tag.

To tag, you'll notice a Tag People field on your Instagram screen when you're about to post a shot. Click anywhere within your photo and a Who's This? bar will pop up. Start typing in the handle of your intended tagee, and people you follow will automatically populate. If you don't know a user's handle, don't fret—type in what you think their handle is or their real name and tap Search. You can do this with as many or as few users as you want, and there's no general rule or best practice when it comes to tagging within a photo; it's just a way to get social while keeping your caption clean. Remember that whomever you tag will get notified and be able to see that you've tagged them (this includes your crush, ex, and boss—whom I, too, wish you could tag in the funny *Office Space* post that would probably get you fired).

When I post outfit photos, I like to tag the brands I'm wearing or where I am (phone cases, luggage, nail salons, and other items and places are totally fair game). Why? Because then I can help my followers discover new brands, see what I'm wearing, and find out where to get that manicure. Tagging helps build goodwill within the community, and you'll find that businesses, friends, and family will actually want to repost your stuff. Think of it as your account marketing strategy.

There's another way to show love to the Insta community: the "@ mention." It's like a tag, only it appears in your caption instead of within your photo. Because I'm such a fan of clean captions, I use these sparingly. But they should definitely be incorporated as part of your caption routine to make your posts as socially friendly as can be (no one likes an Insta hermit).

When you add the @ symbol in front of someone's username, they become discoverable to the community, which can then tap on their handle to see their account and grid (unless they have a private account, of course).

Always remember to be yourself when writing your captions. Make a joke or an observation, or simply say when you like—or don't like—something you're encountering. As mentioned above, try to organically fit in an @ mention when you can. (Even if you're posting a photo of a magazine cover you like while visiting your favorite coffee shop, chances are that both have Instagram accounts and are just waiting to be tagged by patrons such as yourself.)

Just like with tags, this method of sending love to the community alerts anyone you've @ mentioned and ups your chances for getting reciprocal love.

HOW TO USE MENTIONS IN COMMENTS

"Going to miss NYC but it's time to head back home to L.A. Thank you @thenomosoho for letting me wake up to this view every morning."

"Acai bowl after my morning workout sesh with @bodiesbypatrick."

"Celebrating my good friend @louiseroe's first book."

Leading the Conversation

Another time to use the @ mention is when you're commenting and engaging in conversation, one of the most important things you can do on Insta.

As you've heard me repeat throughout this book, you can use your Instagram feed however you want. Not everyone wants to take it seriously, and it works just as well if you only want to share cat photos with your best friends (no judgment here). If you do want to grow a following, though, you'll need to get into the habit of interacting with the community. Instagram is all about sharing photos, likes, and comments. And that means you have to engage with fellow users. The platform works best when you become part of the conversation—commenting on other users' posts, double tapping photos that come up on your feed, and responding to your followers. It does not work when you're a lurker who simply scrolls through your feed with nary a "like."

Being sociable on Instagram isn't, say, building a clean-energy wind turbine; just get into the habit of interacting with other users so you build a relationship with not only your followers, but the people and businesses you follow, too. Easy.

Here's how you do it:

Don't ignore comments. I usually get upward of 150 comments for every picture I post, and when I post four times a day, that number really adds up. But I make an effort to respond to as many comments as I possibly can. When someone comments on one of your photos, you should try to make an effort to respond, too. Thank them. Answer their question. Ask a question back. But whenever possible, don't ice them out.

Comment on other people's posts. In love with a photo of a friend's new puppy? Have an amazing off-menu order suggestion at the pasta place your cousin just posted? Tell them. When

you comment on other people's posts, you're not only spreading goodwill among the community, you're getting your own username out there and making yourself discoverable to the masses. Doing this is a good way to get people to comment on your photos, too.

Ask a question in your caption. Let your followers know they're in a commenting safe zone by posing questions in your captions. Want to know the best pizza place in Chicago? Curious where to go to watch the best July Fourth fireworks in your town? Ask and ye shall receive.

Don't be a creep. When it comes to commenting on a stranger's photo (something that is absolutely totally acceptable, BTW), the last thing you want is to be considered a creep. Leave the love declarations, prom invites, and business propositions out of it. Don't ask someone to get in touch with you; if you have a legitimate reason for reaching out, send a direct message or use Google to sleuth down contact info from their official website. And never, ever post spam. Posting a get-rich-quick scheme on every photo that comes through your feed is the fastest way to lose followers (and real-life friends).

Share the love. Another good way to spread @ mention love is to alert friends and family to posts they might like. When something makes me laugh out loud or reminds me of an inside joke with a friend, I @ mention that person in the caption of the post so that my friend gets alerted and can share the joke, too.

Timing Is Everything

Whether it's meeting the partner of your dreams, landing that prime corner office, or finding the perfectly affordable Spanish-style apartment complete with fireplace and hardwood floors, timing is everything. And Instagram is no different. The time of day and frequency of your posts are vital when it comes to growing—and retaining—followers.

You've probably unfollowed more than a few accounts that have bombarded your feed with a steady stream of shameless selfies posted thirty seconds apart (I know I definitely have). And think of how many cool photos you've missed because friends in different time zones posted while you were busy getting your beauty sleep (how dare you). It's important to think of your Insta feed like a blog: You're posting content that will be consumed by a specific audience, so delivering that content to your audience in a way that makes sense for them is key.

Here's how to do it:

Know your audience's habits . . . Instagram is the first thing I look at when I wake up in the morning (hey, it's a breaking-news source, too!). That behavior is also true for millions of other people the world over—we like to see what we missed while we were sleeping. Because I put myself in my followers' shoes, I post first thing in the morning when I'm sure to capture eyeballs in their pre-caffeine haze. Instagram is also the last thing many people look at before they go to sleep (guilty here, too). So a later-evening post to capitalize on the pre-bed Insta scroll is also a must.

. . . And time zone. My audience is global, so I can pretty much post at any time of the night or day and know I'll get double taps. But if you live in Cleveland and all but a few of your followers do, too, updating on L.A. time will guarantee that your evening post reaches to your fans while

they're comatose in bed. This applies to posting on vacation, too. Hold off posting until you know your followers are awake.

Post at least once a day. You're probably so sick of hearing me say it, but it's seriously fine if you aren't playing Instagram like you mean it. In which case, post as much or as little as you want. But if you are really trying to grow your following, post something at least once a day. You're not going to be doing something interesting every day (I know I don't), but take extra pictures on the not-boring days so that you always have fresh content to post, even if you haven't left your couch for twenty-four hours. Quality-photo rules apply here: Don't post a dull picture just for the sake of getting something up. Be strategic, plan, and bank various types of "evergreen" photos (photos that can be used anytime and aren't event-specific), and you'll meet your once-a-day quota.

But you can post more than that, too. Because I aim to inspire my followers with fresh fashion, décor, food, and travel shots every single day, I'm an exception to the once-a-day strategy. If I happen to be doing something interesting or am hitting up a cool event, I post three or four times in a day. On other days I'll post less. One post is the minimum. I don't have a maximum, but I don't bombard my followers with photos less than an hour apart. You don't want to risk alienating your followers by blowing up their feed. Not cool.

Space is good. That's great that you have four cool pictures you want to post today. But posting them one after another will offend your followers—you never want to show up back to back on someone's feed. Don't overcrowd (pretend you're dealing with a high school crush; you don't want to be the lurker who always "just happens" to be at the water fountain next to their locker—you're not that thirsty). It's your call on how long you want to go between posts. As long as you commit to the once-a-day rule and post when your following is awake, you can go two, four, six . . . however many hours in between postings. Just as long as you always wait out that first hour.

5

INSTAGOLD

182–201

In our era of #girlboss glory, everyone is poised to rule the world—whatever that world means to them. Instagram allows you to have a direct line to potential employers, clients, customers, and fans, making it easier than ever to harness the power of social media while building your livelihood.

But Aimee, you must be thinking. *It's just a social media platform. Do I really need to use it to help me in my business or career?*

The answer, my friend, is yes. According to a recent report by research firm and think tank L2, Instagram boasts the most engagement and highest conversion from browser to shopper of any social media platform. The same report also mentioned how 92 percent of luxury brands that post on Instagram an average of 5.5 times per week increase their customer base. At New York Fashion Week in September 2015, CFDA finalist Misha Nonoo hosted Instagram's first-ever runway show, eschewing a standard catwalk show and debuting her spring 2016 collection through a series of static Instagram posts. Within a couple hours, she gained two thousand followers who could each preorder the looks she presented at her e-commerce site. If that's not enough to convince you, here's one more: A September 2015 study released by SheKnows Media estimates that 85 percent of all purchasing decisions made in the $14 trillion (yes, *trillion* with a *t*) American market are made by women, 46 percent of whom

turn to Instagram for help deciding what to buy.

Plainly put, Instagram is no joke when business is involved. Of course, you don't have to be (or want to be) the CMO of a Fortune 500 company to put its immense power to use. You can have a flower shop or an eBay or Etsy storefront. You can have a jewelry line that you take to flea markets on the weekends as your side hustle and use inspiring photography on your Instagram feed to corral the masses to your booth. There are so many amazing stories of small-business owners who have gotten their name and products to the right eyeballs because of smart Insta strategies.

Molly Guy, the owner of supercool New York bridal boutique Stone Fox Bride (@stonefox-bride), created an Instagram account for her anti-Bridezilla, Brooklyn-type shoppers with a hashtag story series called #StoneFoxRings, which shares real-life, aww-inducing engagement tales and pictures of diamond stunners—each regularly garnering thousands of likes. Because of this authentic storytelling, future brides from across the country pay close attention to Guy's goods—and her e-commerce site. The buzz she's drummed up with her more than 100k followers has helped her get some impressive press, along with a book deal and writing gigs in *Vogue*.

New York fashion-industry-pro-turned-master-baker Amirah Kassem couldn't afford to create an e-commerce site when she launched her business, Flour Shop, in 2013. But she could sign up for an Instagram account, which—through creatively shooting her artfully edible creations—helped her land cake clients such as Sarah Jessica Parker, Beyoncé, and Versace.

No matter how big or small your work goals (or your number of followers), Insta is an amazing place for marketing and launching products, connecting with customers, showing off a visual portfolio, and even directly making money off outfit posts (yes, really). *Cha-ching*, baby.

So get out the notebook and pay attention, because you're about to get an Insta MBA in the following areas:

- The different ways that you can use Instagram to strengthen your business and career goals
- How to devise a business strategy that makes sense for you
- The ins and outs of affiliate programs, so you can start posting outfit shots that convert to cash, no matter how small your following may be

Time is money, so let's get a move on, shall we?

Devise a Strategy. Before you try to use Instagram as a business tool, you need to determine your main goals (and no, it can't just be "make more money").

Do you want to:

- Sell products?
- Increase your brand awareness and recognition?
- Drive traffic to your blog or website?

Once you identify your goal (it's okay to have more than one, or one that doesn't appear above), resurrect that handy-dandy mission statement we talked about in chapter 1 and make sure your business goals are part of it.

Let's look at this case study. My sister, Dani, owns a jewelry company called Anarchy Street, and she has 121k followers (built organically, I might add) at the time of the writing of this book. Her goals were to accomplish all of the above—gain customers, increase brand awareness and recognition, and drive traffic back to her e-commerce site and blog. She does this in a few ways:

Maintain an authentic feed. Dani's jewelry is designed for our friends—girls who work hard, love fashion and accessorizing their outfits, and always try to have a good time. Because of this, her feed is curated for that kind of shopper and is full of organic content of people wearing Anarchy Street jewelry. These are pieces we all actually wear in our everyday lives, doing regular, everyday things. The content doesn't feel like it's trying too hard—the exact vibe of the line to begin with. If you stay true to your business and give your followers something they can connect with, you will naturally attract like-minded peeps (i.e., fans and potential customers) who respond to and interact with your posts.

Host contests and giveaways. At least once a week on the Anarchy Street feed (@anarchystreet), there's at least one creative contest or giveaway happening. One way Dani does this is to ask that anyone entering please follow the @anarchystreet account, then repost a particular photo she's called out. She asks

followers who want to enter the contest to use a specific hashtag, and soon she has thousands of people hashtagging the name of her business and reposting her photo—which in turn gets viewed by every follower of every person entering the give-away. Get it? I've also known brick-and-mortar retailers who have given extra discounts to people who show a geotagged post from a sample sale, and sales most definitely increased. Get creative about what you need from your following.

Collaborate with influencers. Dani made a list of people who embody her brand and sent them each a piece of jewelry. She didn't ask for anything more than for each of them to enjoy and wear the jewelry. Which they did. So much, in fact, that they took and—in many cases—posted photos of themselves wearing Anarchy Street gear. Dani reposted their images, and mutual love was given all around. You can use this same tried-and-true method with your own clothing line, baked goods, flower company, etc. Do some research and make a list of top Instagrammers and bloggers in your community and your space, and send them a little something with a note. Sometimes they will post about your product, sometimes they won't. But when they do, you'll get organic word of mouth that—unless you're making luxury cars from scratch—is a minimal investment.

Another way to work with influencers is to ask them to take over your business account for a day, which is a great way to get their followers noticing your feed.

No matter what your goal, go back to chapter 4 for tips on growing your audience. You could have the coolest feed and most creative contests in the world. But if you aren't hashtagging, geotagging, commenting, and posting every single day, no one will discover your feed and your numbers will stay stagnant.

Not everyone wants to use Instagram for his or her own business. You might be in school or a freelancer in a creative field looking to pick up jobs. In this case, use Instagram as your portfolio to highlight your strongest work and overall aes-

thetic. If you're an illustrator, post photos of your process and studio space and always give yourself a visual pat on the back whenever your work appears somewhere notable. Same goes if you're a graphic designer who just launched a limited-edition collection of notebooks at a local stationery shop—show them off! Are you a writer whose latest article made it into the city newspaper? Put that paper underneath your cup of caffeine and poached-egg breakfast and let your followers know that they, too, can see your name in print that morning. Instagram is not a place for being shy but, rather, for celebrating your accomplishments with the community. So go forth and do you.

Just beware: If your feed is public and you are using it in a professional capacity, stay away from party photos, #freethenipple shots, and anything else that you wouldn't want a future boss to see (no shots of you napping at work). I know young girls follow me, as do many of the luxury fashion brands that I work with, so I choose to stay away from posting any alcohol or wine shots (which is pretty easy, considering I don't drink!). But I still abstain from posting pictures of my friends doing anything that even resembles debauchery, even when I know it's purely PG. Decide how you want to conduct yourself and stick to it. Even when something is deleted, screenshots can always come back to haunt you.

Affiliate Programs

What is an affiliate program, you ask? *Entrepreneur* magazine says it's a marketing strategy that allows a company to "sell its products by signing individuals or companies ('affiliates') who market the company's products for a commission." Plainly put for our purposes, an affiliate program is when a blogger or Instagrammer posts a link to a product on a designer's or e-tailer's website, then gets a percentage of every sale they help drive. Easy, right? The products you can get on commission include everything from plane tickets, jewelry, furniture, clothes, beauty products . . . the list literally never ends. If you really wanted, you could sell your followers paper towels off of Amazon.com. Honestly, every item ever is fair game.

Affiliate programs were overhauled in 2005 by a smart Southern Methodist University student named Amber Venz Box—a blogger herself—who decided that there had to be a better, visually driven way for the chic set to make money off their content. And soon her company, rewardStyle, was born. RewardStyle (rewardstyle.com) is the go-to affiliate program provider for so many of my fellow bloggers (yep, I use it, too). It has a simple-to-use back end that feels like an endless catalog of cool stuff and allows you to build outfit posts with goods from thousands of designers and stores, each giving you anywhere from 5 to 30 percent of each sale that comes from one of your readers. Working with rewardStyle is a fun way to get paid doing something we'd all be doing anyway just because it was enjoyable (or I would, at least).

As far as Instagram is concerned, rewardStyle has a free feature called LIKEtoKNOW.it, which essentially makes your Instagram outfit posts shoppable. This works when your users sign up for the feature. Then, anytime they double tap on an outfit post you've tagged with LIKEtoKNOW.it

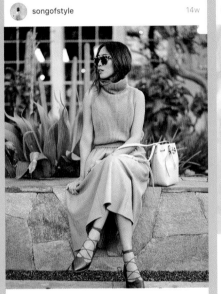

songofstyle — 14w

♥ 44,955 likes
songofstyle I love a good camel on camel action @liketoknow.it www.liketk.it/1WYdq #liketkit

songofstyle
The James Hotel — 6d

♥ 39,452 likes
songofstyle Prettiest shade of blue. Merci @chloe www.liketk.it/2aUbB #liketkit #ChloeGIRLS

songofstyle
JW Marriott Los Cabos Beach Resort & Spa — 4w

♥ 38,540 likes
songofstyle Spa time! 🏋 #jwloscabos

1 2 3

1 In this post, my entire outfit is linked with LIKEtoKNOW.it so my followers can buy what I'm wearing.

2 More LIKEtoKNOW.it action. Once my followers sign up, they can double tap the post to get emailed an e-commerce link to the Chloé bag. So easy.

3 I was invited to the opening of the JW Marriott in Cabo, and they asked that I showcase parts of the hotel that I loved for my followers. Obviously, I was way into the spa.

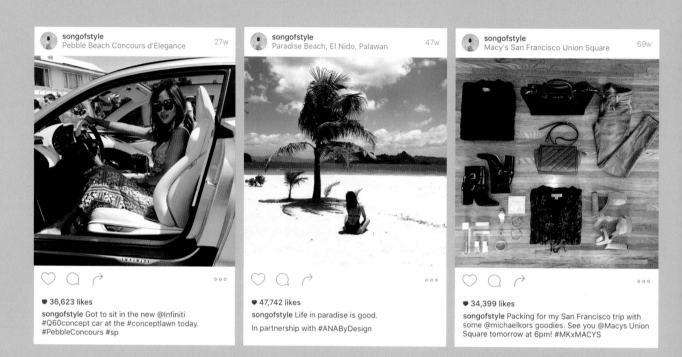

songofstyle
Pebble Beach Concours d'Elegance 27w

♥ 36,623 likes
songofstyle Got to sit in the new @Infiniti #Q60concept car at the #conceptlawn today. #PebbleConcours #sp

songofstyle
Paradise Beach, El Nido, Palawan 47w

♥ 47,742 likes
songofstyle Life in paradise is good.

In partnership with #ANAByDesign

songofstyle
Macy's San Francisco Union Square 69w

♥ 34,399 likes
songofstyle Packing for my San Francisco trip with some @michaelkors goodies. See you @Macys Union Square tomorrow at 6pm! #MKxMACYS

123

3 I worked with Infinity during the 2015 Concours d'Elegance in Pebble Beach. I used different hashtags for the event, model of car, and location.

2 I was asked to travel to the Philippines with Japanese airline All Nippon. Because I was paid, I noted "in partnership."

3 I was asked to host an event at the Macy's San Francisco store for Michael Kors and shot a flat lay to remind my fans to join.

items, they'll automatically get an email with all of your outfit credits and links where to buy them. Pretty sweet, huh?

Because this method only works when your followers do, in fact, sign up, a big part of being successful with LIKEtoKNOW.it is properly educating your following.

There are a few ways to do this:

- Post an Instagram shot with a caption announcing that you're on LIKEtoKNOW.it. Once you start posting outfit photos that are tagged with affiliate items, space out gentle reminders every so often that you would love your followers to sign up.

- If you have a blog or Facebook page, post to LIKEtoKNOW.it there, too.

Believe it or not, LIKEtoKNOW.it isn't actually a huge part of my Instagram game, because while cold, hard cash is always nice, this method doesn't really fit into my bigger Insta purpose of producing beautiful images that inspire people. I don't want to make money on every photo I post,

so I use it sparingly and strategically, and only when I'm wearing or using a product that I think my followers will actually love. (Another perk of the affiliate program is that you essentially get to pretend you have a new career as a buyer. How cool is that?)

There are definitely other players in the affiliate program game. Google has one, as does Amazon and even eBay. A company called Skimlinks works with larger publishers such as Refinery29 and Apartment Therapy. It's important to find an affiliate program that works best for your needs and offers you a commission rate that feels competitive (the standard rate is 8 to 20 percent of a sale). What I personally like about rewardStyle is that it was started by style bloggers with style bloggers in mind, so it's extremely visual, easy to use, and very community-oriented (most of the company's account reps are also style bloggers, so they understand that the struggle can be real).

Working with Brands

Of course, there are other ways to leverage your platform prowess beyond moving merchandise. And you don't have to have millions of followers to make a business deal worth someone's while. Even if you have a small following (that's under 10k in most circles), you can still work with smaller companies, start-ups, and other brands you really love, as long as your following is engaged. (Do they comment on your photos en masse and never miss one of your meet-ups? Then they will likely buy product or regram branded content, too.)

I'm in the incredibly lucky position that brands usually approach me when they want me to help promote their items. But when I was first starting out, I worked with clothing companies for free and took killer photos for them so they would think of me again when they could pay me (not to mention talk me up to others in need of my services). Working with brands for free was also an amazing way to learn how to conduct myself (send thank-you notes, never demand anything for free, and always be polite and friendly) and the mechanics of Instagram partnerships, in general.

Unless you have a large following and are already getting contacted by companies, here are two things to keep in mind before reaching out to a potential partner: The easiest way is to email or DM the brand and talk about how much you like them. Pitch a collaboration that is mutually beneficial for both you and the brand. Don't just ask for free stuff and expect to not put in any work. You need to create content that the brand will appreciate in order to create a good working relationship with them. When I work with a brand, I always send them a preview of my photos before I post and make sure there is clear communication about the concept.

What can you offer the brand? Web traffic? Instagram followers? E-commerce sales? Amazing content that you will style in a unique, innovative way? The collaboration has to make sense for both you and the brand, so think about what value you bring to their table.

Am I only doing this to score a freebie? Sure, you can email Dior and ask for a free pair of $400 sunglasses to post on your 1k-strong Instagram feed. But chances are, you'll hear back from them never. If you're only thinking about a potential partnership because you want the swag, the partnership is probably not meant for you.

Branded Posts

A branded post is when you get paid to post an Instagram shot on behalf of a brand. Think of yourself as a billboard and that a company is merely buying some advertising space. Branded posts are usually birthed when an organization (be it a clothing company, beauty line, hotel, jewelry store, or just about any other business you can think of) contacts you because you have a following that they want to reach, whether in sheer numbers or high levels of engagement.

This type of post usually entails the brand asking you to use a specific product in a photo, using a specific hashtag in your caption, and tagging the company's account. When I do this, I always keep creative control over how I post a product or location (since the company contacts me, I can only assume they like my style and aesthetic enough to let me do my thing). And I genuinely want to take a gorgeous photo that offers the brand a return on their investment. I don't want to get paid to take a crappy photo.

But branded posts can get tricky for a few reasons. For me, deciding whether or not to work with a brand always goes back to my mission statement and whether or not I actually like the products I'm being asked to advertise—not the amount of money I'm being offered. I once turned down a really large sum of money to work on branded posts with a company that I just didn't love. They weren't part of my mission statement's vibe, and I really felt in my gut that turning them down would allow me a better opportunity to work with the kinds of brands I really, truly love. It was really hard to walk away from the money, but I knew that if I stayed true to myself, it would later pay off in spades—I always like to think long term and usually forgo instant gratification— and it has.

If you're the kind of person who will post anything for a paycheck, no judgment (I get it—there are mouths to feed). But if you do have more of a long-term strategy and want to build a reputable brand, ask yourself these questions before deciding to work with a company:

- Do I like this product?
- Would I be happy endorsing this product a few months from now?
- Are my followers going to like this product?

If the answer is no to any of the above, reevaluate and go back to your mission statement. And really think about what your Instagram business goals are in the first place.

Takeovers

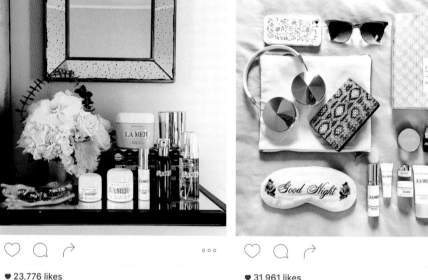

♥ 23,776 likes

songofstyle Beauty doesn't stop at night. My nighttime beauty routine consists of applying @lamerofficial moisturizing soft cream, the regenerating serum, and the illuminating eye gel that I'm obsessed with! Make sure to follow @lamerofficial's instagram as I'm in charge of it for this week! #lamereditorinchic

♥ 31,961 likes

songofstyle My @lamerofficial in-flight travel essentials. I'll be taking over @lamerofficial's Instagram this week, so make sure to follow and check out my must-haves! 🖤 #lamereditorinchic

Sometimes brands will want you to do a takeover, or "take over" their account for a specified period of time while alerting your followers to check out the takeover—and, subsequently, the company's feed. This is a great way for a company to grow followers and also for you to get your voice and content up on their feed.

Pricing

Knowing what you are going to charge for your services—whether you are a small-town grammer with 15k followers posting about a local jewelry store's sale or a major street-style star with a fan army two million strong—is vital. When I started, I didn't even know that I could get paid for taking pictures—something I loved enough to seriously do for free. There's no right or wrong number to charge for your services. But do your research. Ask other bloggers and Instagram personalities what they charge for similar activities. Think about the size and engagement of your following in relation to other people who you know are getting paid for their work. Most important, decide how low you're willing to go while still being comfortable with the deal. When I first started out, I got taken advantage of by a really huge clothing company that asked me to film a video series for them—with hair and makeup on my dime—while paying to fly myself from school in San Francisco to L.A. I later decided that, while working for free can be a great thing to help build momentum, I wasn't willing to spend a ton out of my own pocket to make it happen. You have to feel good about the deals you make, so don't be afraid to be a #boss and politely yet confidently ask for what you want.

By now, I hope you feel confident and inspired to grab your phone and start taking pictures of the things you love with purpose—or, if you've already been doing that, you feel ready to take your mobile photography and social media game to an entirely new place.

Writing this book was an amazing experience because it made me realize that I have truly made a living from my passion—and that's the real message I want to impart to you now: It's possible for you to document a life you really enjoy living, whether you want to turn this newfound knowledge into a job, use it to help score a project, or keep it as a hobby. There's no right or wrong way to use Instagram, as long as you document your life in a way that makes you proud (#word).

I don't want you to close this book obsessing about how many likes you got on your last photo (though now you should feel like you know how to up that number) or scrutinizing how many followers you get every day (though that number, too, will rise if you paid attention here—just saying). I hope you are inspired to take photos that remind you of your happiest times—even if those are simply eating at the best taco truck ever—and to share those times with a following who cares.

Instagram is an incredible community, and I'm excited we get to be in it together. I hope we continue using it to connect, motivate, and celebrate the visually beautiful moments that compose our lives.

So thank you for reading and letting me be part of your journey. I truly feel #blessed.

Aimee Song

XOXO AIMEE

So much love and effort was poured into this book, and I wouldn't have been able to do it without such an amazing team.

Thank you, Karen Robinovitz, for encouraging me to write this book in the first place while we were getting pedicures on a very cold day in New York. Vanessa Flaherty, my manager, and Maddy Gorin from my DBA team—if you guys hadn't chased me with deadlines, this book never would have been finished. Your constant support helped this free-spirited dreamer stay on track. Thank you for being my champions while I wrote this book.

To my editor, Camaren Subhiyah—thank you for being so patient with me despite all of my travels and late deadlines and bad Wi-Fi connections! Thanks for your tireless help and guidance through this whole process. Writing a book and getting it published isn't easy, but you made it seem doable, and I can't thank you enough.

Thank you, Sebit Min, for the beautiful design of this book. You knew exactly what I wanted—it's gorgeous.

To my main assistant, Nicholas Pak—I'm so glad we met through Instagram (how appropriate!) and got to travel the world together. Thanks also to sweet Christina Choi from my team; we couldn't do it without you.

To my *halmunee* (that's "grandma" in Korean), who I inherited my hard work ethic from: You were always my constant inspiration whenever I fell into a rut or had a block.

Thank you to Erin Weiner, my writing partner, who innately understood my voice. I will never forget all the avocado toasts we ate while brainstorming at the coffee shop on Pico. Even though we got yelled at for hogging their tables

with our laptops, we finished it together.

Thank you to my mom and dad for raising me to be an independent woman and for never putting me in a box. Because of this, I've always had the confidence to do big things, and this love and encouragement have given me the strength to write my first book. Of course, my love of fashion came from my mom and I can't thank her enough for letting my sister and me be ourselves when society was telling us to be otherwise.

Thank you to my number one supporters, my sister, Dani Song, and my love, Jacopo Moschin. Dani and Jacopo, so many of the travel images were shot with (and by) you guys and no matter the amount of time I spend with you both, I never get tired of you two. I can't wait to make more memories and dream up our next big trip. I love you guys so much!

Another big thank-you to Jacopo for reading and rereading this book and staying up with me while I finished it in the wee hours.

And last but not least, thank you to the amaz-ing followers of *Song of Style*. Thank you for being part of my journey throughout the years and for giving me the motivation to continue on. Whenever I get emails, tweets, comments, or DMs from you guys, it really brings a big smile to my face and helps me do better. Without you, this all would be merely a quiet journey.

EDITOR
CAMAREN SUBHIYAH

DESIGNER
SEBIT MIN

PRODUCTION MANAGER
TRUE SIMS

Library of Congress Control Number:
2015955306

ISBN: 978-1-4197-2215-8

Printed and bound in the United States
10 9 8 7 6 5 4 3 2 1

Abrams Image books are available at
special discounts when purchased in
quantity for premiums and promotions
as well as fundraising or educational
use. Special editions can also be
created to specification. For details,
contact specialsales@abramsbooks.com
or the address below.

ABRAMS
The Art of Books

115 West 18th Street
New York, NY 10011
abramsbooks.com